Giuliano Valdes

ART AND HISTORY OF
PISA

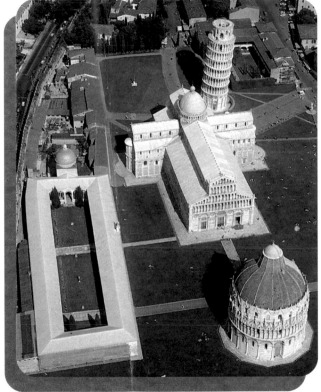

Photographs by
ANDREA PISTOLESI

This book is the first to present an exceptional photographic documentation of the monumental complex of the Piazza dei Miracoli.

By using an elevator the photographer was able to take the Piazza dei Miracoli with angle-shots that were quite unlike the "earthbound" point of view. This expedient was particularly

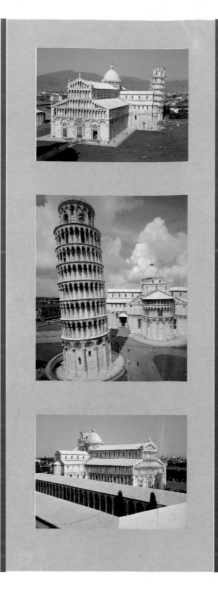

useful in the shots of the Leaning Tower: by placing the camera lens at the center of the Tower it was possible to highlight the tilt of the various floors which resulted when the ground first gave way after the third ring of the Tower had been brought to completion. This special effect is particularly telling in the photo on page 40.

Printed in Italy by Centro Stampa Editoriale Bonechi

Translated by Erika Pauli

The Publishing House wishes to thank Piero Pierotti, Professor of Town Planning History at the University of Pisa; Giampiero Lucchesi, in charge of the Artistic Legacy Sector of the Opera Primaziale Pisana; Dr. Alessandro Canestrelli, in charge of "Publicity" for the Pisa Tourist Promotion Bureau, for their kind collaboration.

Photographs from the Archives of Casa Editrice Bonechi taken by Andrea Pistolesi, with the exception of photographs on pages: 4, 81 above, 98-99, 100, 120 taken by Giuliano Valdes-Editing Studio, Pisa

ISBN 978-88-8029-024-7

INTRODUCTION

Objectivity and impartiality are essential requisites for all those who hope to describe their native city without rhetoric or glorification, proud simply of being part of a great tradition of History, Art and Culture. It therefore almost seems absurd that someone born on the shores of the 'Mezzogiorno' of 'its' Arno and whose heart beats for the blue and white colors of the 'Tramontana', on the other bank, should take on this task that is anything but easy.

After this brief autobiographical digression and a rather explicit reference to the Gioco del Ponte, one of the most exalting realities of the history and folklore of Pisa, let us get to the heart of the matter, Pisa itself, which consists of much more than its Campanile, famous as it may be. Even though advertising blurbs in many of the guidebooks and the weary commonplaces of the mass media still see Pisa as «the city of the Leaning Tower», the time has come for all, Pisans or not, to admit to a much vaster reality, which comprises many other monuments of great historical interest and outstanding artistic significance.

The city, with its ancient civic and cultural traditions and an illustrious historic past, a first-rate artistic attraction, a major service and communications center, spreads out on either side along the sunny banks of the largest river in Tuscany. As the Arno lazily describes a rather pronounced loop through the city, the heart is gladdened by the enchanting views of the spacious lungarni (streets along the banks of the Arno), so spectacular and full of light. The felicitous geographic site in northern central Italy, the ease with which it may be reached by means of an integrated and functional transportation system, the advantages of a mild maritime climate, the vicinity of the Natural Park of Migliarino-San Rossore and its central position with respect to other sites of noteworthy tourist interest (Versilia, the Apuan Alps, Montecatini Terme, other Tuscan art cities) make Pisa a dynamic reality in the panorama of tourist Tuscany.

We have said that Pisa is more than just the city of the Leaning Tower. And we wish to reaffirm it now, more convinced than ever, at the very moment in which the well-known vicissitudes of the fate of its most representative monument keep the whole world with baited breath.

The current 'offbounds' to the public of the city's leading attraction must not induce tourists and visitors to confine their visit to Pisa to a hurried tour of the Piazza dei Miracoli.

The 12th-century walls with the marble Lion. *Following page:* the Campanile of S. Nicola.

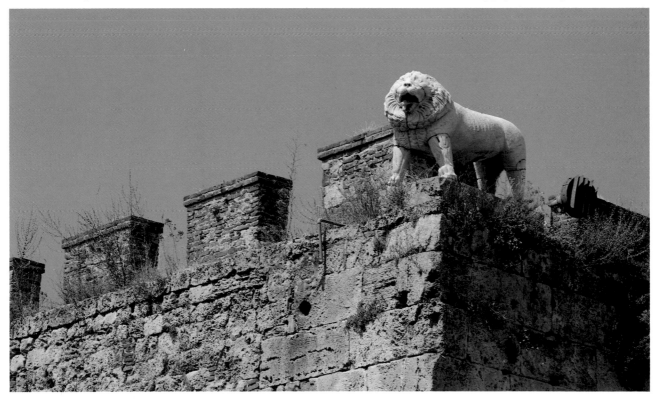

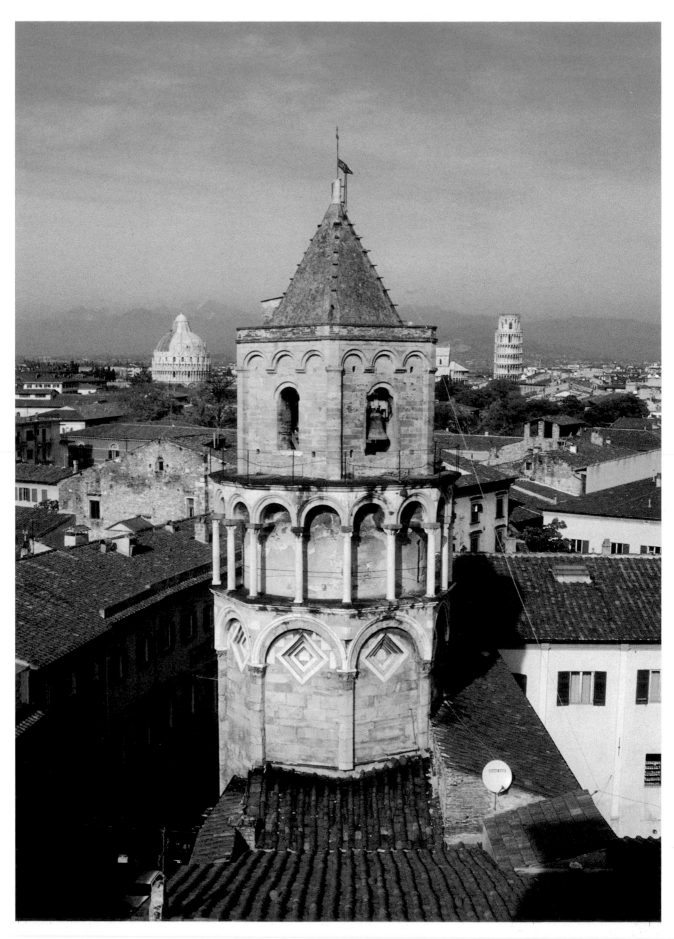

HISTORY

If the most remote origins of Pisa and of its name are inevitably lost in myth and legend, the most recent historiographical acquisitions, abetted by archaeological finds, testify to far distant Eneolithic settlements and the certain presence of the Etruscans between the 6th and 3rd centuries B.C. It is most likely that Ligurian colonists of Celtic origin settled here even earlier, anticipating Greek colonization. Moreover, even though the legend of Pelops, who left the shores of the Alfeo (a river in the Peloponnesus) for those of the Arno to found a new Pisa, in perennial memory of his land of origin, is indirectly supported by Virgil himself in the 10th book of the Aeneid, we know with certainty that Pisa was a port of call in trading with the Greeks. In the Etruscan period Pisa, situated near the extreme northern border of Etruria, was certainly influenced by Volterra but never became more than a modest village of fishers and skilful shipbuilders, which depended in part on the instability of the coastline and the periodical floods of the Arno. As Etruria was romanized, Pisa grew in importance and was an ally of Rome in the long wars against the Ligurians and the Carthaginians. The port (Portus Pisanus), at the time situated between the mouth of the river (in those times near where San Piero a Grado stands today) and that portion of the coast now occupied by Livorno, constituted an ideal naval base for the Roman fleet in the expeditions against the Ligurians and the Gauls, and in the operations aimed at subjugating Corsica, Sardinia and other coastal zones of Spain. Pisa, ally of Rome, then became a colonia, a municipium, and in the time of Octavianus Augustus (1st cent. B.C.) was known as Colonia Julia Pisana Obsequens. In the meanwhile the growth in population, the development of shipbuilding and trade — fostered by the establishment of the Via Aurelia and the Via Aemilia Scaurii as well as by the harbor — meant an expansion of the inhabited area which was soon surrounded by a circle of walls. The imperial city was noted for the magnificence of its public and private buildings: although at present traces of 'Roman life' in Pisa are scarse (Baths of Hadrian, improperly called the 'Baths of Nero', capitals from the age of Severus, 3rd cent. A.D.) there seems to be little doubt as to the existence of a Forum and a Palatium as well as an Amphitheatre, a Piscina, a Naval Circus and numerous temple structures, replaced by churches in Christian times. Recently (June 1991) excavations carried out near the Arena Garibaldi have revealed the presence of an Etruscan necropolis on which a domus augustea was laid out in Roman times. The first Christian ferments were introduced into the area of Pisa by Saint Peter himself, who landed 'ad Gradus' in 47 A.D. So goes the legend, so deeply rooted however that a basilica was subsequently built here.

With the fall of the Roman Empire, Pisa passed first under the Lombards and then under the Franks. In the early Middle Ages the city's maritime vocation burgeoned and soon contrasted with the Saracens, who were aiming at full supremacy of the Mediterranean. With bases in Corsica and Sardinia, they frequently threatened the lands controlled by the Church itself. The story of Kinzica de' Sismondi is well known. This young Pisan heroine is said to have saved the city from a Saracen incursion while most of the Pisan army and fleet were out driving the infidels from Reggio Calabria (1005). Bctwccn 1016 and 1046 the Pisans conquered Sardinia, and Corsica too in the end (1052), thus laying the bases for an effective control of the Tyrrhenian Sea as opposed to the Saracens. After these successes the city, with Papal consent, sent the fleet to Sicily to support the struggle of the Norman Roger I and Robert against the Saracens. After breaking the chains of the harbor of Palermo, the ships hoisting the Pisan Cross in a field of red (the city's standard since the exploit of Sardinia) defeated the enemy (1062) returning home with such rich booty that they were able to begin the construction of the Cathedral.

In the meanwhile rivalry with Genoa had broken out in a first naval conflict, victorious, opposite the mouth of the Arno (6-9-1060), while in a larger Mediterranean theatre the Pisan fleet successfully took part in the First Crusade. These positive results helped the Maritime Republic consolidate its position in the Near Eastern ports of call and in particular in Constantinople. The subsequent conquest of the Balearic Isles, terminated in 1115, and the victory over Amalfi (1136), coincided with the peak of the city's maritime and military power. But the 13th century was to be fatal to Pisa, whose standing in the Western Mediterranean had in the meanwhile equalled that of Venice in the Adriatic and the Eastern Mediterranean. The continuous rivalry on the seas with Genoa and fierce constrasts with the Guelph cities of Tuscany (headed by Florence and Lucca) led to an inexorable downfall. As a result of its unconditioned support of imperial policies, but above all because of the seizing of a group of ecclesiastic dignitaries who were on their way to Rome to take part in a council which could have ended in the removal of Frederick II of Swabia (1241), Pisa was excommunicated by the Pope, and had to wage a bitter struggle on two fronts — against Genoa (which also declared Guelph sympathies) and against the Tuscan cities which had by then become members of the Guelph League. The disastrous consequences of the war on land against the Guelphs and the burdensome conditions consequently imposed by the Florentines (1254), and in particular the collapse of the Ghibelline ideal, were paralleled by events on sea: in the fateful waters of the Meloria on August 6, 1284, the day of St. Sixtus, a date up to then propitious for the Republic, an astute naval maneuver of the preponderant Genoese fleet, commanded by Oberto Doria, wiped out the Pisan galleys, under the command of the Venetian Alberto Morosini and Andreotto Saracini. It was absolutely impossible for Count Ugolino della Gherardesca, who was defending the port of Pisa, to come to the aid of the fleet, which suffered heavy losses, and at least 10,000 prisoners were taken.

The subsequent attempt of Ugolino (who in the meanwhile had become podestà) to impose a neo-Guelph

restoration in Pisa, ceding possessions and castles to the eternal Florentine, Luccan and Genoese rivals, earned him the undisguised hostility of the Ghibelline faction, and this together with what had happened at Meloria, led to new accusations of betrayal. In March of 1289 the Ghibelline faction, with Archbishop Ruggeri degli Ubaldini at its head, prevailed, and Ugolino, with his children and grandchildren, was sentenced to die of starvation in the Torre dei Gualandi. In the meanwhile the peace of Fucecchio (12-7-1293) imposed new and onerous conditions in favor of the Florentines, and the hopes aroused in Ghibelline Pisa by the ephimeral episode of Henry VII of Luxemburg was to no avail. With the advent of the podestà Uguccione della Faggiola, valorous Ghibelline condottiere, Pisa took its revenge, conquering Lucca (1314) and drastically defeating the Florentines and their Sienese and Pistoiese allies at Montecatini (29-8-1315). Subsequently, the prevailing party struggles in the city (in which the philo-Florentine merchant faction headed by Gambacorti was long opposed to the anti-Florentine faction comprised of nobles and entrepreneurs, headed by the Gherardesca) led the Genoese to force the harbor and carry off the chains, which they showed off as a trophy for many years (at present they are once again in Pisa, in the Camposanto). On the land front, the Florentines were once more victorious at Cascina (28-7-1364). The subsequent signoria of Piero Gambacorti seemed to inaugurate a period of relative peace and prosperity but his treacherous assassination (21-10-1392) by hired killers instigated by the Visconti, handed Pisa over to the lords of Milan. In 1405, with base bargaining, they traded Pisa off to the Florentines for money. The indignation and fierce resistance of the Pisans was weakened by a series of negative events: in the end the city had to surrender after a siege.

This episode (9-10-1406) marked the irreversible fall of the glorious Maritime Republic. The subsequent advent of the French king Charles VIII aroused new hopes of independence in the city but the Florentines hastened to gather under the walls of the invincible rival and once more besieged it together with their allies. The indomitable resistance of the Pisans was so strong the Florentines even thought of deviating the course of the Arno and called on Leonardo da Vinci. But the idea remained on paper for Pisa, exhausted by famine, had to accept the Florentine signoria (20-10-1509). The Medici government of Cosimo I resulted in a renaissance in the city: university activity was rationalized and augmented, various public offices were organized, and, most important, the Order of the Knights of St. Stephen was instituted (1561), bringing new lymph to the Pisan maritime traditions, and taking part in the epic naval encounter of Lepanto (7-10-1571). In that circumstance the Christian fleet, the expression of a coalition of European powers (the papacy and Spain, Venice and the House of Savoy and still others), under the leadership of Don Juan of Austria, assisted by Gian Andrea Doria, Marcantonio Colonna, Ettore Spinola and Sebastiano Veniero, wiped out the maritime power of the Ottoman Turks captained by Mehemet Ali. Subsequent Medici rulers achieved important public works, such as the Aqueduct of Asciano (1601) and the Canal of the Navicelli — between Pisa and Livorno (1603). In the early 1630s a fierce plague raged through the city. With the advent of the Lorraine government which obtained the sovereignty of the Granduchy of Tuscany in 1738, as established by the treaty of Vienna, the rationalization of the cultural institutions began (the Scuola Normale was once more opened, 1847).

The epic of the Risorgimento also involved the citizens of Pisa: on the unforgettable day of Curtatone and Montanara (28-5-1848) the volunteers and the university students, who had cut off the tips of their university caps in order to aim their guns better, wrote one of the most glowing pages of the first war of independence. The year 1860 marked the plebiscite adhesion to the Kingdom of Italy: two years later Pisa bestowed a warm tribute on Garibaldi who had been wounded on the Aspromonte. The most recent history of the city includes the devastating destruction of World War II and the barbarous episode of Kindu (ex Belgian Congo) where thirteen pilots of the 46th Air Brigade, on a humanitarian mission under the aegis of the United Nations, were massacred (11-11-1961). Five years later a disastrous flood of the Arno resulted in the collapse of the Ponte Solferino and the partial destruction of the Lungarno Pacinotti.

Bas-relief with the entrance to the Harbor of Pisa (Leaning Tower).

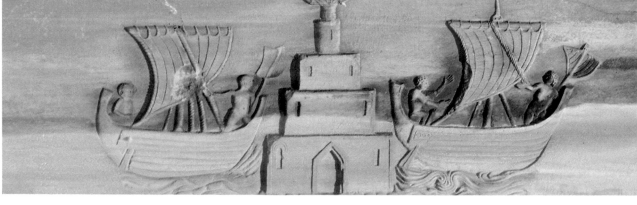

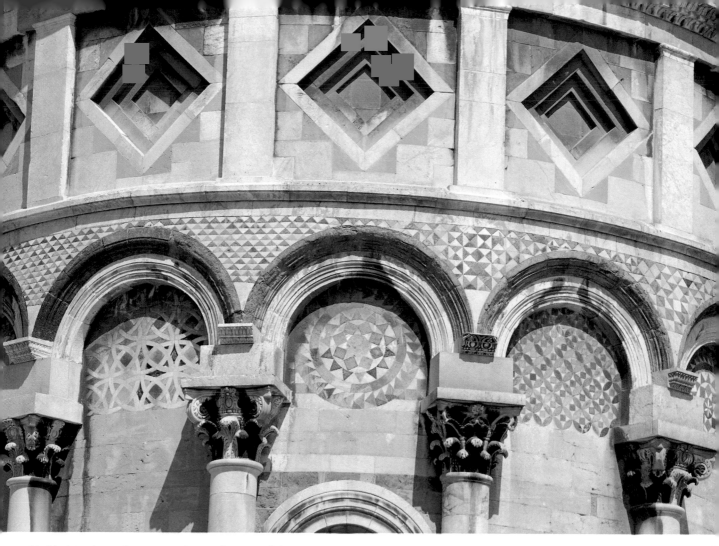

Marble intarsias and ornamentation on the apse of the Cathedral.

PISAN ROMANESQUE

During the Romanesque period, art and architecture in Pisa developed characteristic features and themes that resulted in a well-defined style that came to be known as Pisan Romanesque. In that period, between the 11th and 13th centuries, the flourishing of art and architecture in the city coincided with the period of greatest splendor of the Republic, fated to make its exit from the stage of history, as protagonist, at the turn of the 13th century. Romanesque architecture in the city, which had burgeoned as if by magic on the lawn of what was to become the Piazza dei Miracoli, with, one after the other, the Cathedral, the Baptistery, the Campanile and the Camposanto, includes Lombard features (the superposition of loggias, piers and arcading) integrated with motives of classic, Roman-Christian (Latin-cross plan) and Byzantine art (dome of the Cathedral), fusing in a marvelous architectural crucible influences of unquestionable Islamic extraction. While the cathedral was the model for other significant Romanesque churches in the city (S. Frediano, S. Paolo a Ripa d'Arno), in a sense all the places of worship of the times, in Pisa and in the environs, in their solemn and majestic nature faithfully mirror a historical period that was particularly prosperous for the Republic. The Basilica of S. Piero a Grado, for instance, but the Pieve of Calci, the Pieve of S. Giulia and the Pieve of Cascina — all in the immediate surroundings — also present the unmistakable features of the current that had affirmed itself in the city. Pisan Romanesque spread throughout the neighboring centers, all the way to the island of Elba (churches of S. Stefano alle Trane, S. Giovanni, S. Lorenzo), to Corsica (Cathedral of Nebbio, Church of S. Maria Assunta), to Sardinia (Badia di Saccargia, Basilicas of S. Pietro di Torres, S. Pantaleo di Dolianova, S. Maria di Tratalías). Pisan influences are also to be found in Puglia (cathedrals of Trani, of Troia and, in the same city, the Church of S. Basilio). In Tuscany mention can be made of religious buildings permeated by strong Pisan Romanesque accents in Lucca (Cathedral of S. Martino, churches of S. Michele in Foro and S. Frediano), in Pistoia (Duomo, Church of S. Giovanni Fuorcivitas), in Prato (Cathedral) and in Arezzo (S. Maria della Pieve).

7

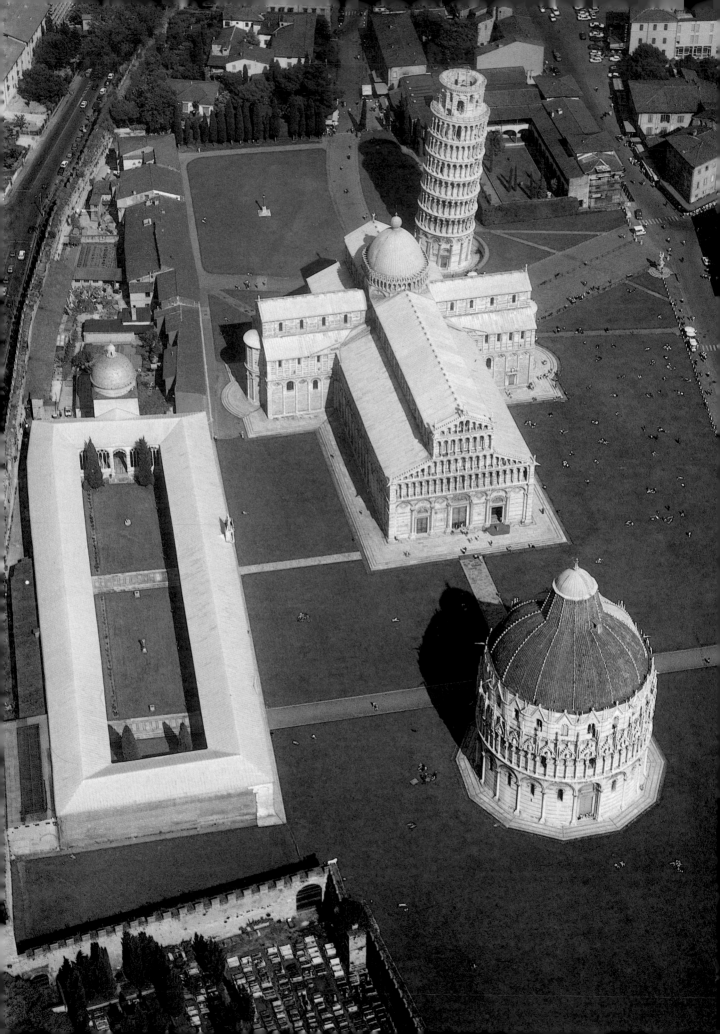

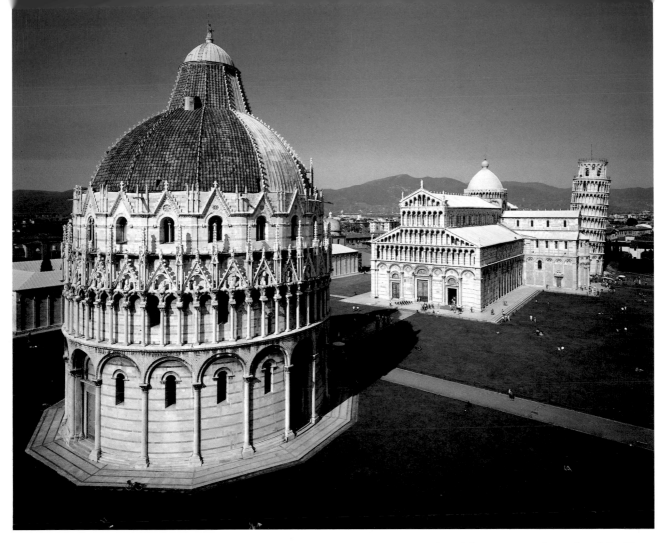

◀ Bird's-eye view of the Piazza dei Miracoli.

View of the monumental complex of the Piazza dei Miracoli.

PIAZZA DEI MIRACOLI

The famous square, whose real name is *Piazza del Duomo*, is often improperly called *Campo dei Miracoli*, even by such famous people as the Italian writer Gabriele d'Annunzio. One of the most evocative and striking urban layouts in the world, at first sight the visitor is struck with marvel at the view surpassing description of the finest expressions of religious art the city has to offer, perfect in their geometric and spatial synchrony and rising, as if by magic, from a soft green lawn. On two sides the turreted walls of the Republic, one of the best preserved of medieval circuits, testifying to the power achieved by the city, act as an ideal backdrop. The splendor of the candid marble, the precious intarsias and inlays, the movement created by the arches, the loggias, the columns, the aediculas and the statues lend an almost unreal, fascinating dimension, enlivened by a varicolored composite throng of tourists who linger till late in the evening, until the square finally stands almost deserted with the moonlight bathing the transparent beauty of the

monuments. There seem to be reasons to believe that the site of the present piazza was considered a sacred area as far back as Etruscan times. Excavations in the Fifties documented the existence of a Lombard cemetery set on top of Roman remains of still older date. The religious pole of Pisa developed outside the early medieval city, even though close by, on a site that appeared strategically easier to defend and that was less subject to flooding. In Roman times the *Palatium* of the emperor Hadrian stood here while references exist to an early Christian baptistery built on the site of the present Camposanto Monumentale. Subsequently this zone outside the city was chosen as the location for the church dedicated to *Santa Reparata*. But the determining event that led to the construction of the first monument — the **Cathedral** — in the area which was then to become the Piazza dei Miracoli, was the victory of the Pisan fleet over the infidels in the harbor of Palermo on the glorious day of San Sisto (August 6, 1063), which became a memorable date in the annals

of the Republic of Pisa and is still now celebrated officially. On that occasion it was decided to 'invest' the wealth taken from the Saracens in the construction of a temple that would be consecrated to Christianity, but which would above all stand as a symbol for posterity of that victorious undertaking. That this is what happened seems to be supported by the lack of written references (inscriptions, plaques) of a religious nature, while those of panegyrical content, both military and civil are plentiful. Construction of the **Baptistery** (1152) and of the **Walls** (1155) then followed. The latter, built by Cocco Griffi, are none other than the second belt of urban walls, essential in the defense of the city but above all needed to safeguard the great religious monuments then under construction. Still today these imposing defensive works, with crenellation and dominated by the square *Tower of S. Maria*, are an integral part of the enchanting setting of the complex of the Miracoli. Mention must be made of the *Porta del Leone* — so-called after the marble lion set on the walls (beyond, closed by a gate, is the *Jewish Cemetery*) — and the imposing *Porta Nuova*, with three passageways, which offers a picturesque composition of the monuments to anyone coming from *piazza Manin*. On that side the entrance bears the Medici heraldic bearings, while on the part facing the Piazza dei Miracoli it is decorated by a striking shed roof. Work for the construction of the **Leaning Tower** began in 1173, while that of the **Camposanto Monumentale** was undertaken in 1278 in order to provide proper burial grounds for the tombs that had previously simply been set against the Cathedral or in adjacent areas. In later medieval times, dwellings, rural and religious buildings began to crowd around the monuments, which must have looked quite different from today. In 1820 a rural dwelling, situated between the Baptistery and the Hospital, was demolished. In 1860, a Committee for the study of the isolation of the monuments was established. The subsequent transformations of the urbanized layout of the area around the Duomo of Pisa, with the demolition of the house of the 'Becchino' (situated between the camposanto and the walls) and above all of the *Chapter House*, the opening of the *via Cardinal Maffi* and the moving of the *Church of San Ranierino* (once in the vicinity of the Tower, near the south-western side of the building which currently houses the Museo dell'Opera del Duomo, with the facade facing west) set the bases for the final arrangement of the Piazza dei Miracoli, as admiringly contemplated today by so many tourists.

A striking vista of the Cathedral and the Baptistery.

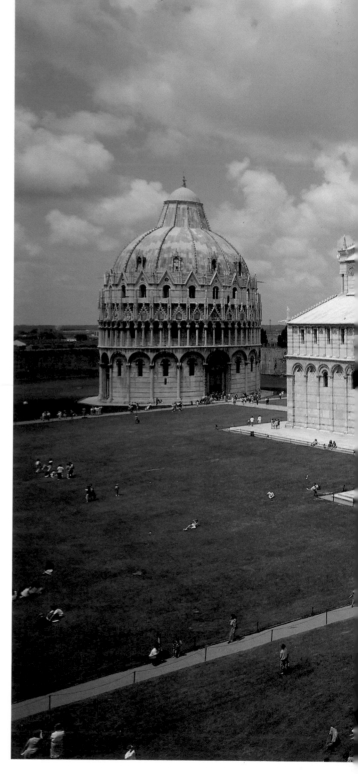

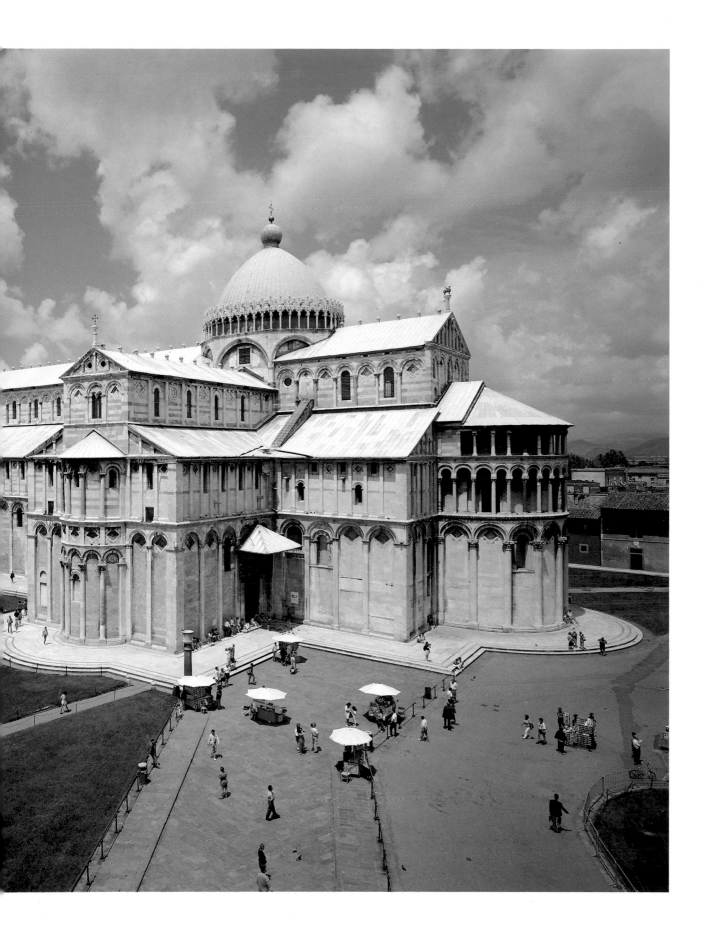

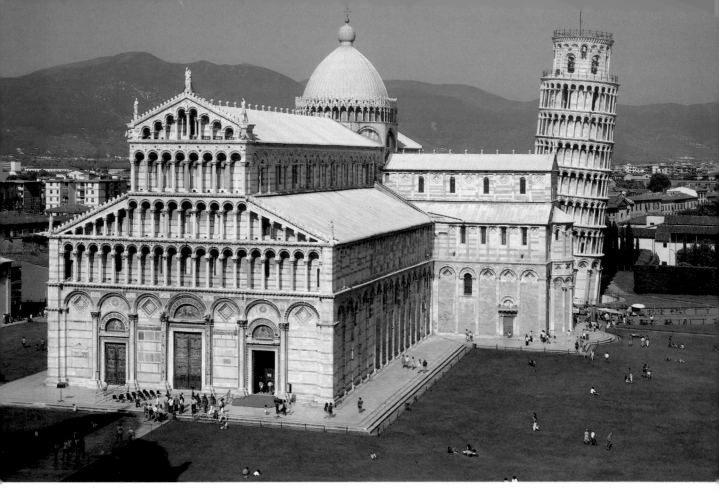

The Cathedral and the Leaning Tower.

Two details of the splendid facade of the Cathedral ►
with its wealth of decoration.

CATHEDRAL OF S. MARIA ASSUNTA (DUOMO)

The Cathedral of Pisa is an inseparable part of the marvelous four-piece ensemble of masterpieces of architecture and art which makes the *Piazza dei Miracoli* what it is. The group of buildings so scenographically set in the piazza del Duomo of Pisa leave the visitor with an impression in part real and in part unreal, like a fairy tale, due first and foremost to the striking contrast of the white marble with the green lawn and blue sky.

In Roman times the *Palatium* of Emperor Hadrian stood here and subsequently a place of worship dedicated to *Santa Reparata* was built on top. In 1063, after the victory of the Pisan fleet in Palermo, Buscheto di Giovanni Giudice was entrusted with the task of building the cathedral, which was to be the perennial glorification of the splendor of the Maritime Republic. Pope Gelasius II was present at its consecration (26-9-1118), and the subsequent enlargement was terminated around the middle of the 1120s. At the turn of the century Rainaldo, a native of Pisa, finished the luminous facade. In the first two decades of the 17th century restorations were carried out after a fire had gravely damaged the building (25-10-1595).

FACADE

The unforgettable facade rises up, like the entire building, from a broad marble pavement that surrounds it. The lower order, scanned by pilaster strips and crowned by blind arcading in part decorated with lozenges, has three bronze doors, cast by Portigiani, with 17th-century reliefs by followers of the circle of Giambologna, which replaced the originals by Bonanno after they were destroyed in the fire. The four upper tiers, which diminish in height, are pierced by the same number of galleries with marble columns and arches. Decorative sculpture rises on the coping and at the sides of the facade.

A *Madonna and Child*, attributed to Nino Pisano, stands on the tip of the gable, with statues of the *Evangelists* at the corners, and *Angels* right below. Two other statues of the *Evangelists* are set at the end corners of the side aisles. In the lowest tier with a sham portico in which elements of classical architecture are combined with decorative elements of clear Byzantine derivation colored marbles and geometric ornaments, sunken lozenges, bas-reliefs, friezes, cor-

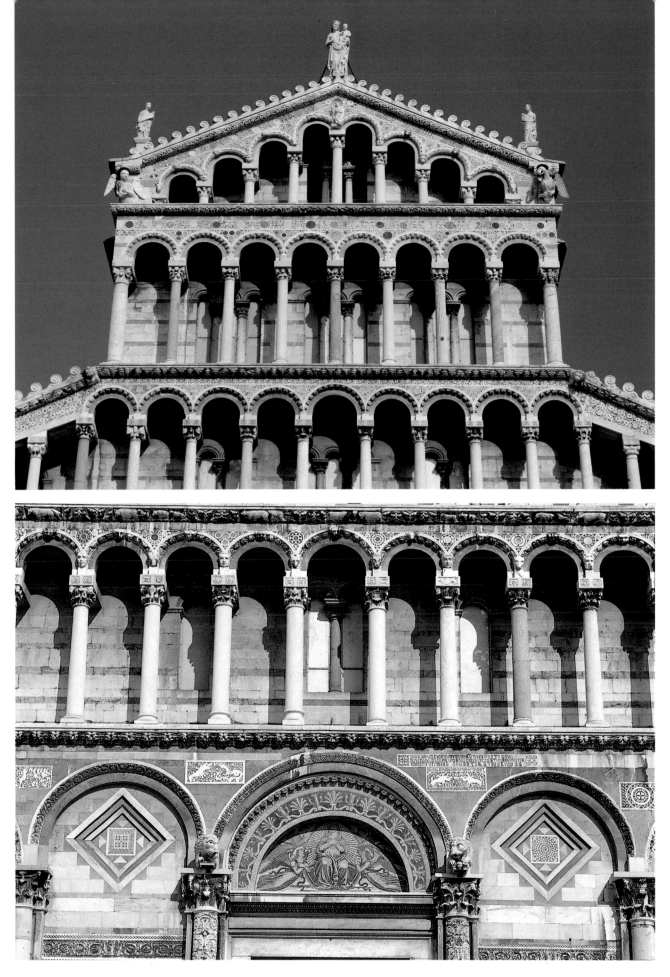

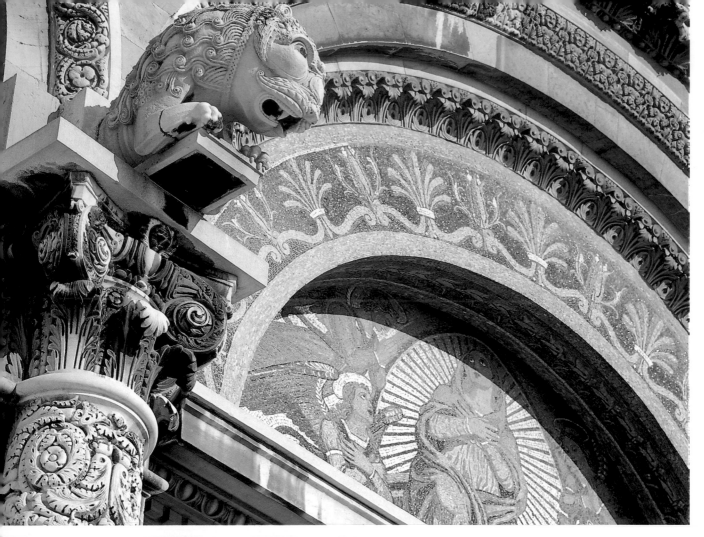

The wealth of sculptured decoration and the iconography of the facade of the Cathedral are highlighted in these two pictures.

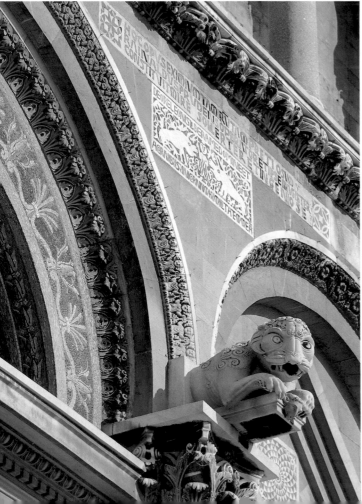

nices, sculpture, but above all polychrome marble intarsias create a particularly rich decorative fabric. The profusion of ornament on the large central portal is the first thing to be noticed. The two engaged half-columns at the sides are decorated with bas-reliefs and foliated capitals, sprouting monstruous figures. The mosaic in the lunette depicts the *Madonna*. It is a 19th-century work by Giuseppe Modena da Lucca, who also did the mosaics on the two side doors. The historiated panels of the bronze doors depict *Events in the Life of the Madonna*. *S. Reparata* (left door) and *St. John the Baptist* (right door) appear in the lunettes of the two side doors while *Episodes from the Life of Christ* are depicted in the bronze panels.

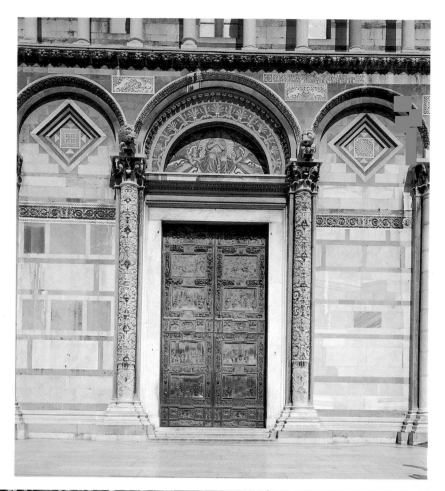

Facade of the Cathedral: the splendid, ornate central portal; a detail of the bronze reliefs depicting scenes from the Life of the Madonna.

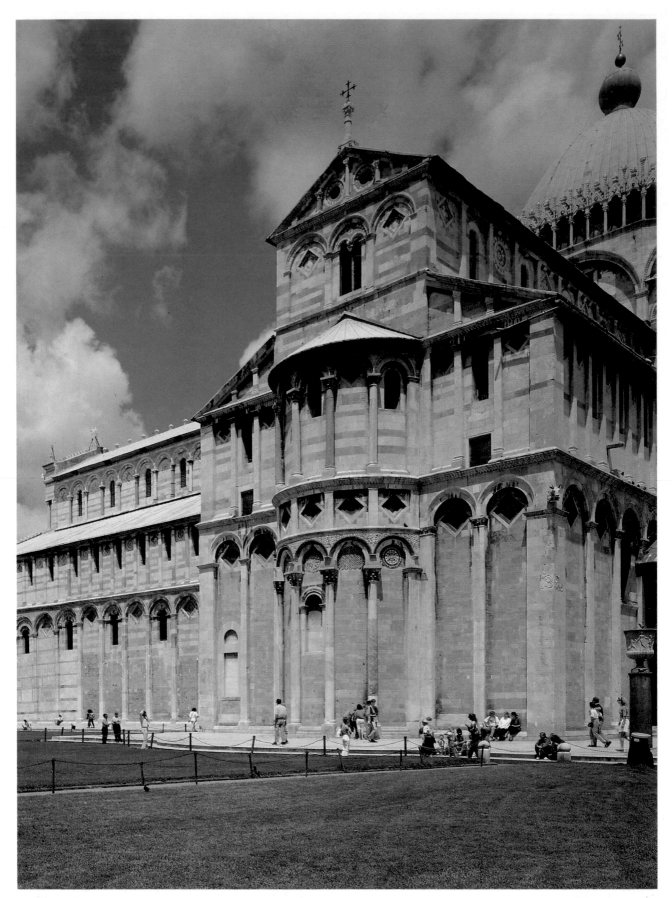

Cathedral: detail of the transept and right side.

A fine view of the dome and transept of the Cathedral with ▶
the Leaning Tower.

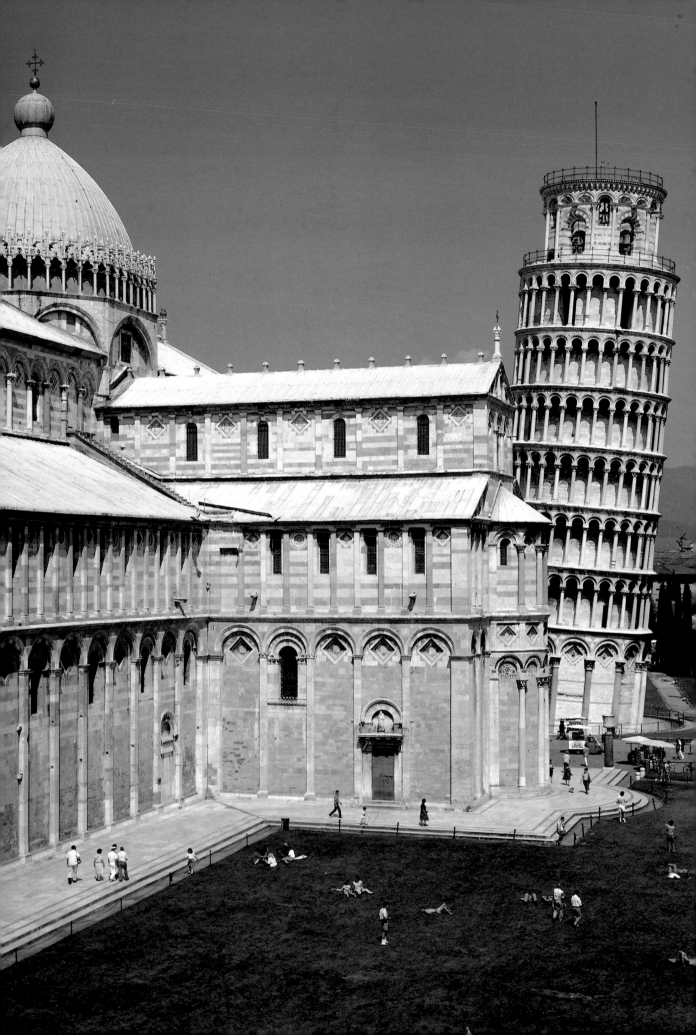

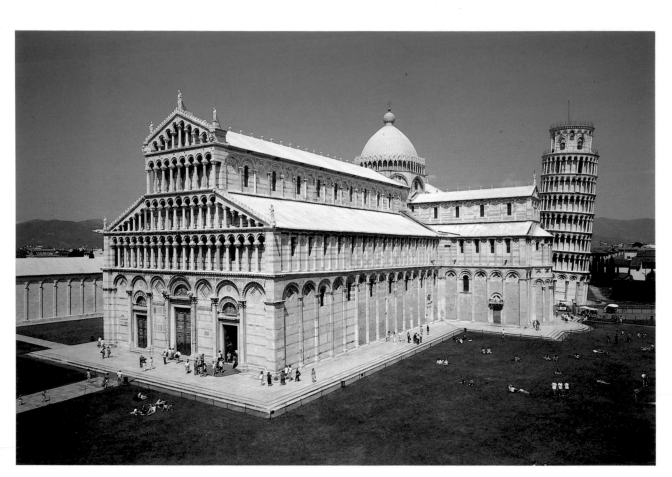

A fine general view of the Cathedral and the Leaning Tower.

An unusual shot of the monumental complex with the Camposanto.

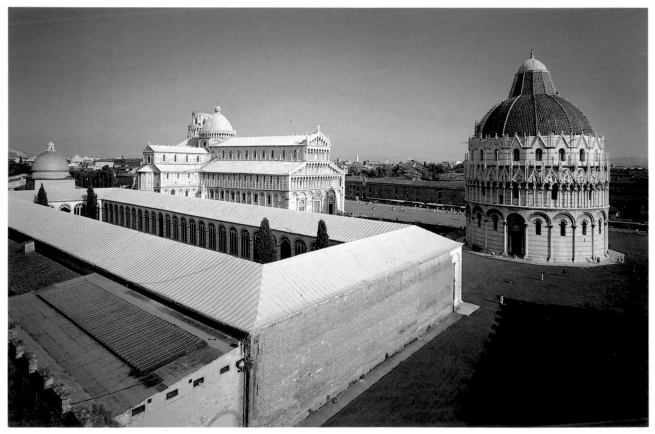

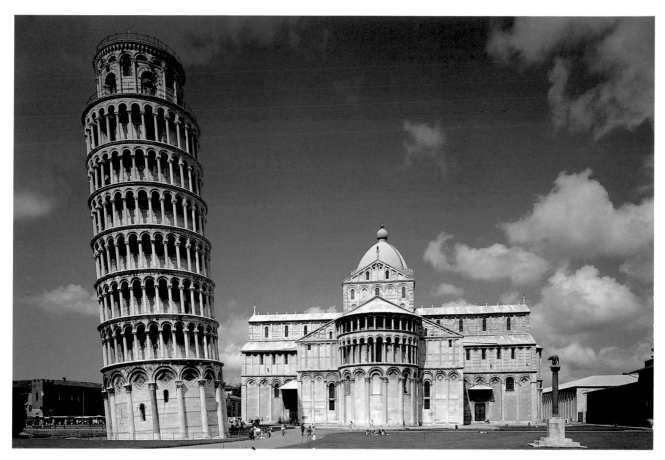

A marvelous picture of the Leaning Tower and the apse of the Cathedral.

A charming shot of the green Piazza dei Miracoli with the Baptistery in the foreground.

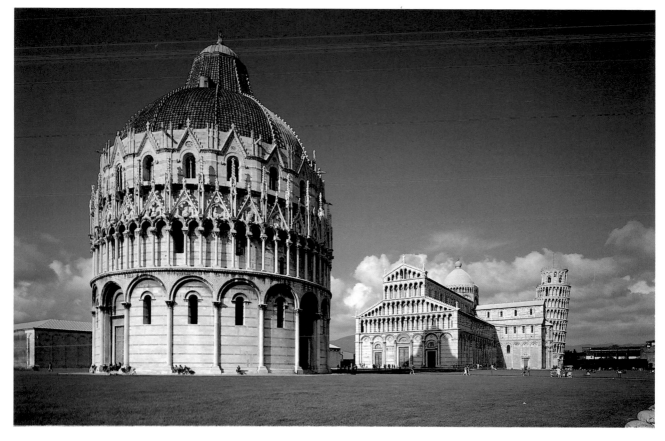

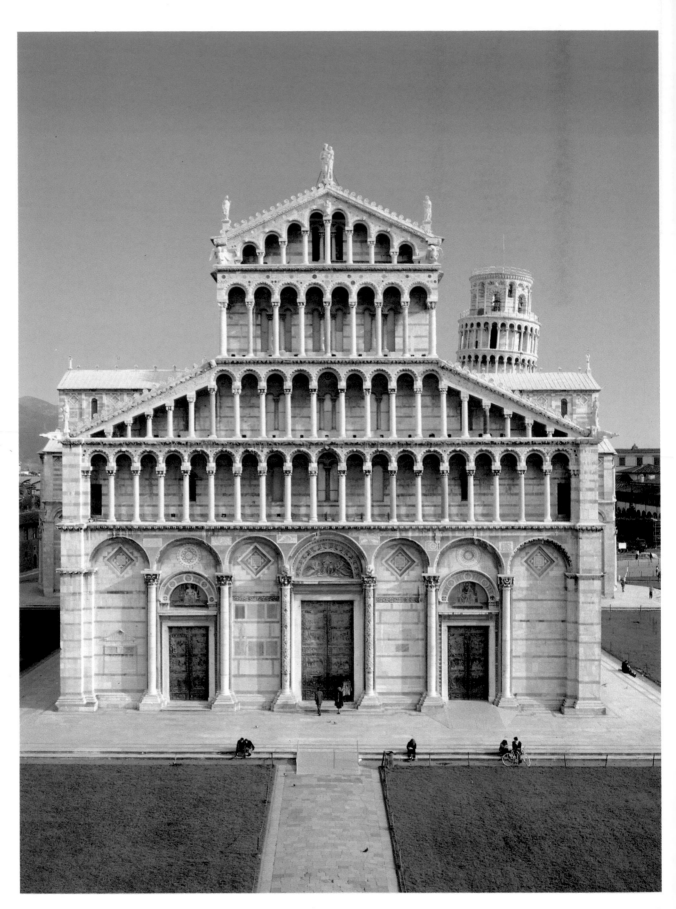

The facade of the Cathedral seen from the Baptistery.

Architectural patterns of the Cathedral apse dominated ▶
by its dome.

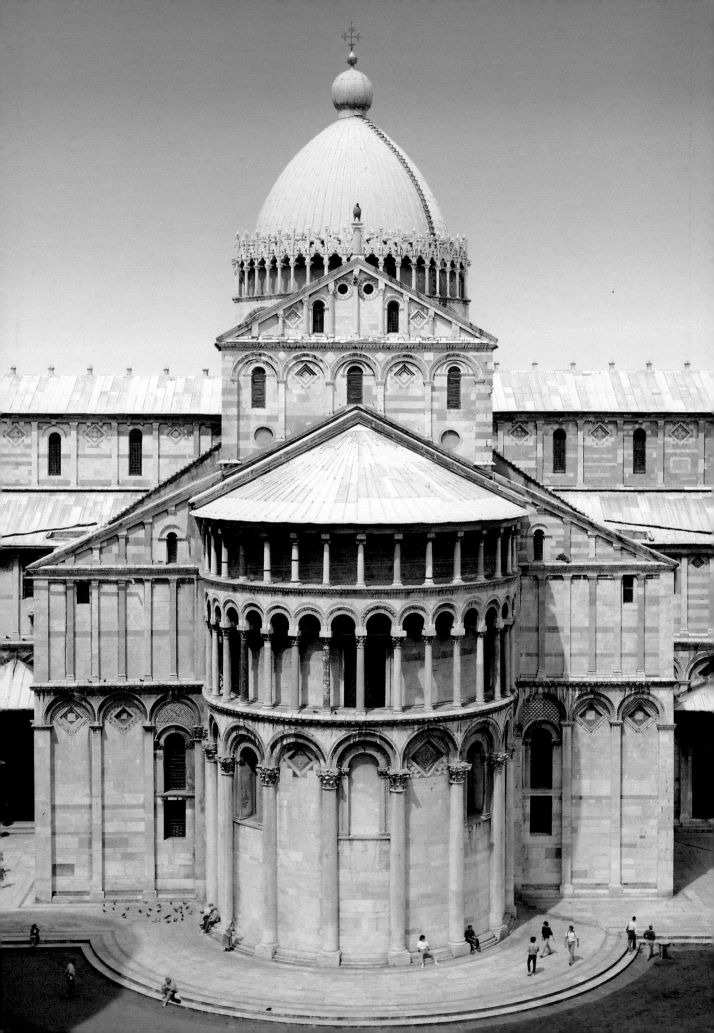

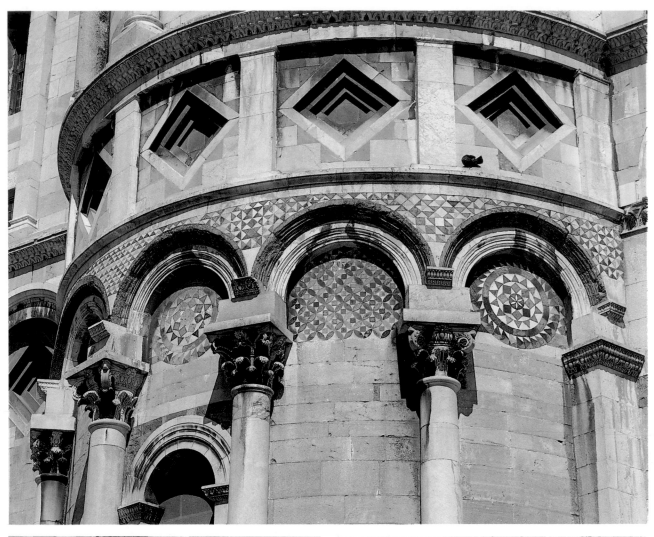

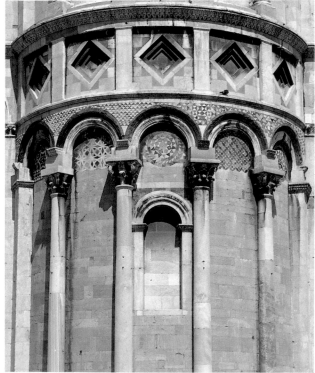

26

APSE

A copy of a Fatimite *griffon* (the original is in the Museo dell'Opera del Duomo) stands on the gable of the nave, overlooking the stupendous apse, beautifully characterized by a colonnaded loggia in two tiers. This part of the Cathedral is also extraordinary for the wealth of decoration to be found in the blind arcading, the sunken lozenges, the colored marbles, friezes, but above all, the precious polychrome marble intarsias in geometric motifs and the mosaics. Moving around the back part of the Cathedral, one is likely to discover ancient inscriptions, bas-reliefs and zoomorphic sculptures.

The marvelous **Porta di San Ranieri,** which leads into the chapel of the same name, opens in the apse portion. The relief panels of the bronze doors are the inspired work of Bonanno Pisano (second half 12th cent.). These *Episodes from the Life of Christ* reveal the influence of Hellenistic and Byzantine art, and that of the Rhine. The relief in the lunette *(Madonna and Child with Angels)* dates to the 15th century and is the work of Andrea Guardi. The lintel is antique and was reused in the Romanesque period.

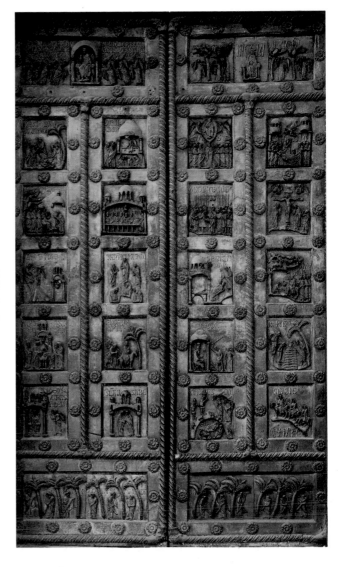

◄ A few pictures which document the variety of marble intarsias on the apse of the Cathedral and the profusion of geometric and carved decoration.

An allover view of the splendid portal of San Ranieri with details depicting the Magi and the Nativity.

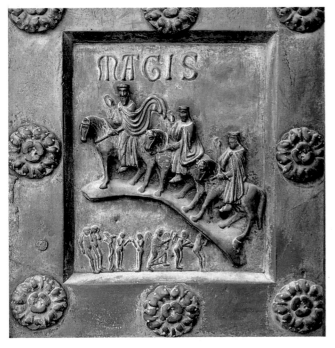

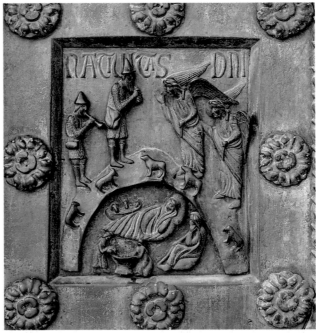

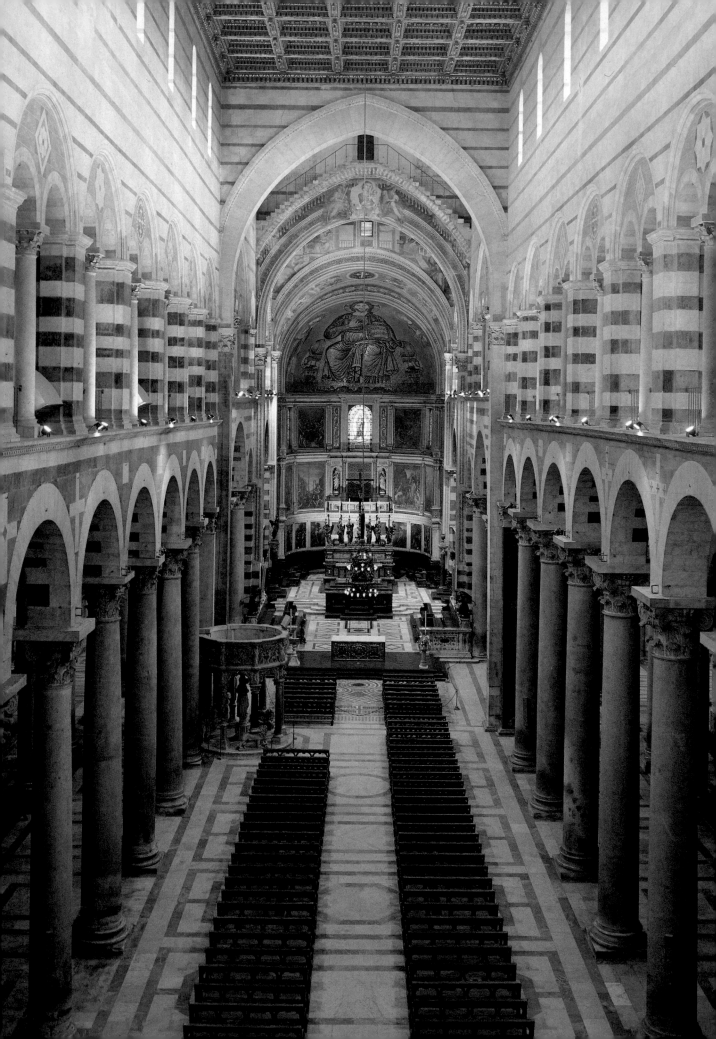

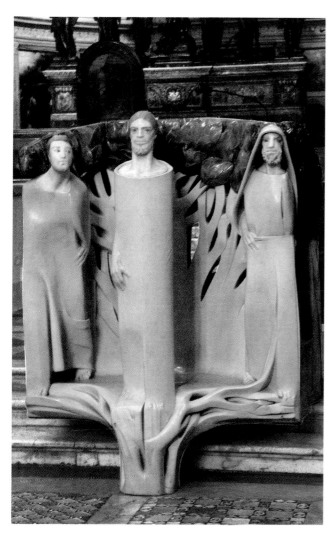

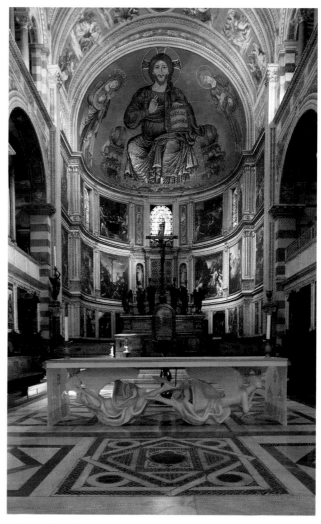

◀ A fascinating view from on high of the nave of the Cathedral with its matronei (women's galleries).

The cathedral's new, Carrara marble altar with two angels in flight was made by Giuliano Vangi. The same artist also made the new marble ambo that is dedicated to the theme of the disciples at Emmaus.

INTERIOR

The solemn majestic interior is haunting in its monumentality. The Latin-cross plan has a nave with double aisles, separated by powerful columns in porphyry and Elba granite. The side aisles have matronei (galleries reserved for the women) above, while the coffered ceiling is by Florentine 16th-17th century artists. On either side of the nave are two holy water stoups (17th cent.) surmounted by bronze sculptures. Near the entrance, on the right, is the *funeral monument of Archibishop Rinuccini,* over which is a *Crucifix* by Pietro Tacca (17th cent.). On the first altar on the right particularly of note are a *Madonna and Saints* (17th cent.) by Cristofano Allori *(il Bronzino);* a *Vestition of Santa Bona* (Antonio Cavallucci, 18th cent.); and a canvas by the 18th-century painter Domenico Corvi *(S. Ubaldesca Restores their Health to the Sick).* On the second altar is a painting by Francesco Vanni *(Dispute of the Sacrament)* with a detail attributed to Carracci and a painting by the 18th-century Pisan artist G. B. Tempesti *(Mass of Pope Eugene III).* Note also the

painting depicting *Richard the Lion-hearted Conceding Privileges to the Pisans* (Giuseppe Bezzuoli, 19th cent.). Of particular note on the third altar are a *Madonna delle Grazie* by Andrea del Sarto and Giovanni Antonio Sogliani and another painting by Sebastiano Conca *(Pietro Gambacorti Receives the Approvation of his Congregation,* 18th cent.). The painting showing the *Blessed Gambacorti Instituting his Order* is by Francesco Mancini (18th cent.). A marble lunette with a trenchant depiction of *God the Father,* by Ammannati, decorates the fourth altar. The cupola, based on Byzantine examples, and decorated with an *Assumption* designed by Orazio Riminaldi (17th cent.), stands over the intersection of the nave and the transept. The fine pavement underneath dates to the first building and is outstanding for the fine stone inlays in pietre dure and colored stones which form geometric designs, and were the work of Cosmati masters.

The famous *Lamp of Galileo* hangs from the vault of the nave. It is said to have provided the great Pisan with the idea that the oscillations of the pendulum, with a certain approximation, have the same duration,

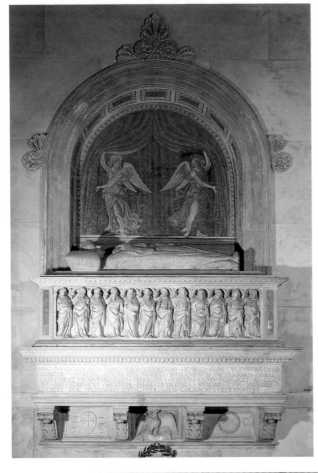

whatever their width (isochronal property of the pendulum). The facts however refute this tale, for the bronze lamp was placed in the cathedral four years after Galileo's discovery (1587). The inspiration for his deductions of physics is said to have been a common lamp swinging back and forth in the cathedral.

Near the left pier of the cupola is the *Pulpit* by Giovanni Pisano, taken apart after the fire in the Cathedral (1595), preserved in fragments in the storerooms and then exhibited (late 19th cent.) in the Museo Civico, at the time part of the complex of the convent of S. Francesco, before being reconstructed here in 1926. A splendid piece of work, circular in plan, sustained by columns and sculpture, it is richly decorated by fine deeply carved reliefs which make this pulpit one of the

Chapel of San Ranieri: the tomb of Henry VII of Luxemburg (Tino di Camaino).

Cathedral: the so-called 'Lamp of Galileo' and the rich coffered ceiling.

The nave of the Cathedral seen from the high altar.

Cathedral: the splendid circular marble pulpit (Giovanni ▶ Pisano).

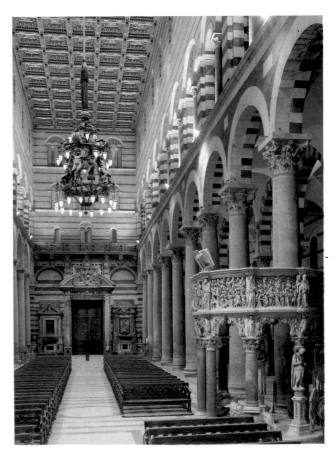

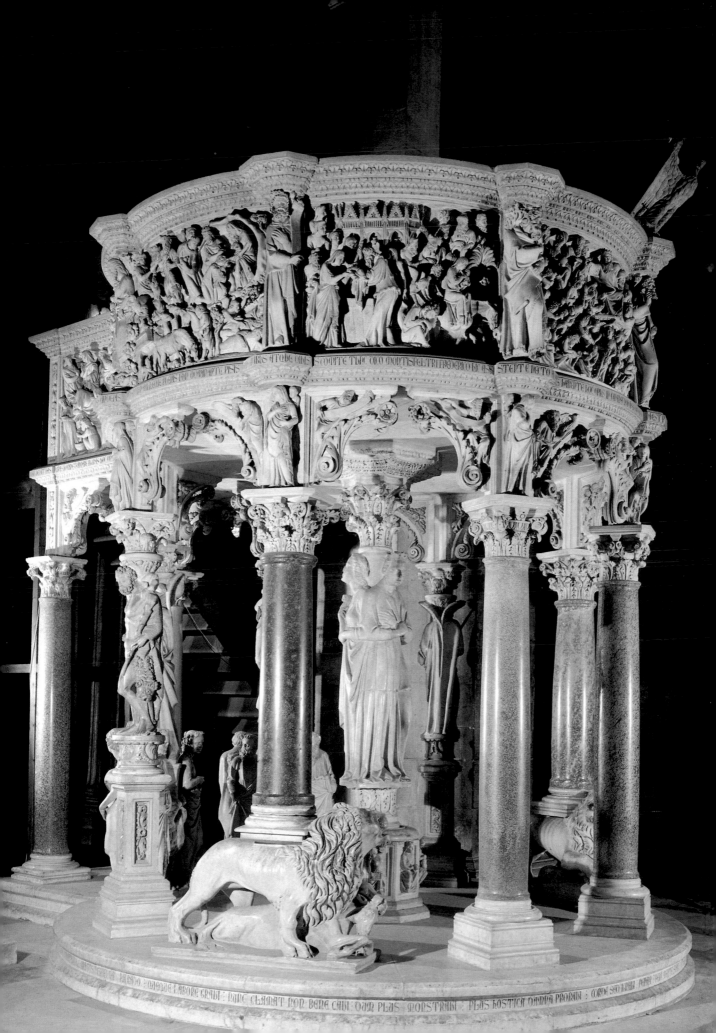

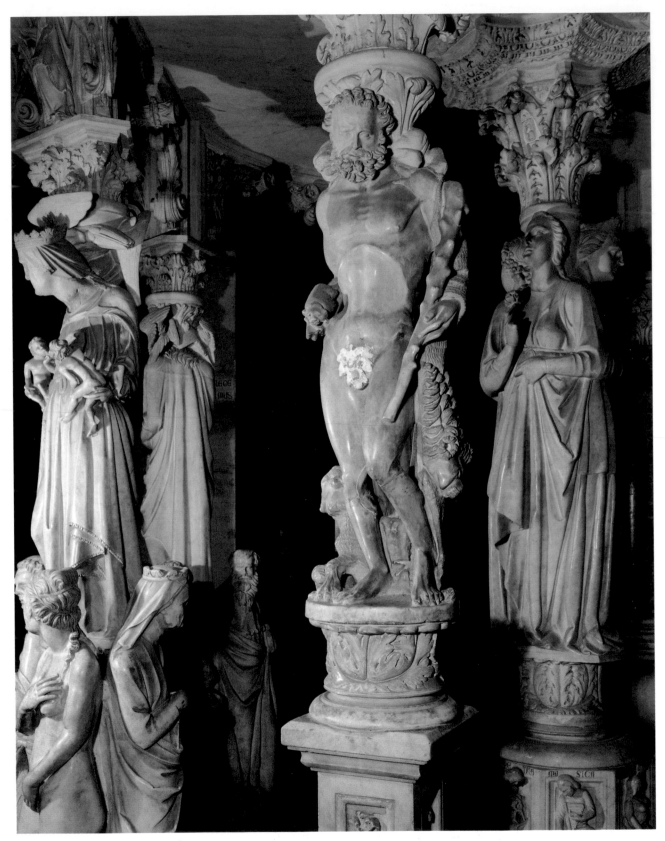

Giovanni Pisano's pulpit: detail with Hercules.

32

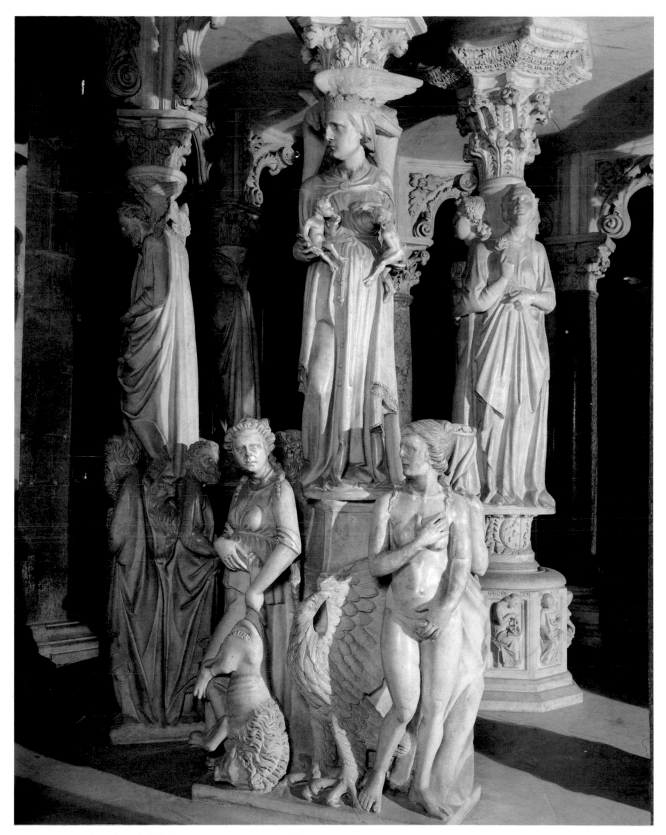

Giovanni Pisano's pulpit: detail showing the Church
supported by Justice, Temperance, Fortitude and Prudence.

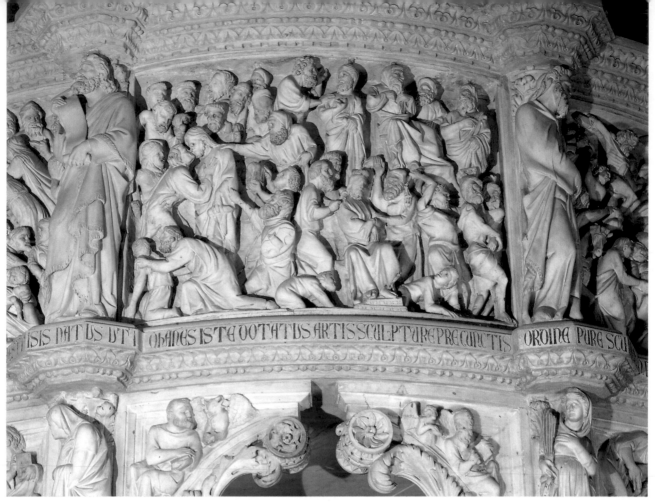

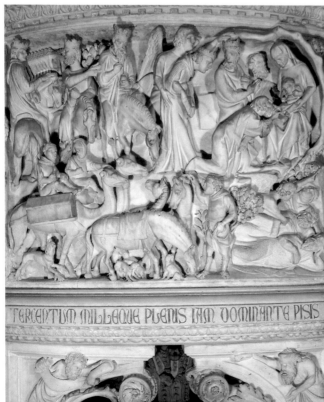

These illustrations furnish an idea of the wealth of sculptural decoration on Giovanni Pisano's marble pulpit. In addition to the figures already shown, mention must be made of the central group under the pulpit, depicting Faith, Hope and Charity; then there are St. Michael and Christ supported by the Evangelists. The marvelous high relief panels above depict the Birth of St. John the Baptist, the Annunciation, the Nativity, the Adoration of the Kings, the Presentation of Christ in the Temple, the Flight into Egypt, the Slaughter of the Innocents, the Betrayal, the Passion of Christ, the Crucifixion, the Elect and the Damned.

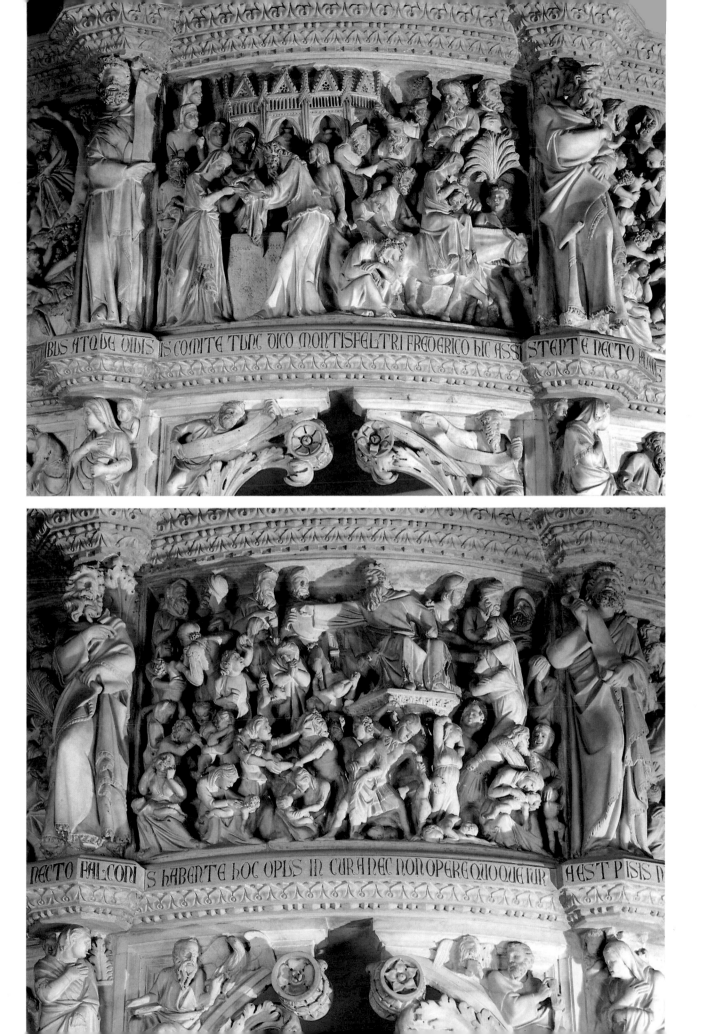

BDS ATQVE VIBIS IS COMITE TVNC DICO MONTISFELTRI FREDERICO HIC ASSI STENT E NECTO FALCONIS

NECTO FALCONI S HABENTE HOC OPVS IN CVRA NEC NON OPERE QVOQVE FVR A EST PISIS IN

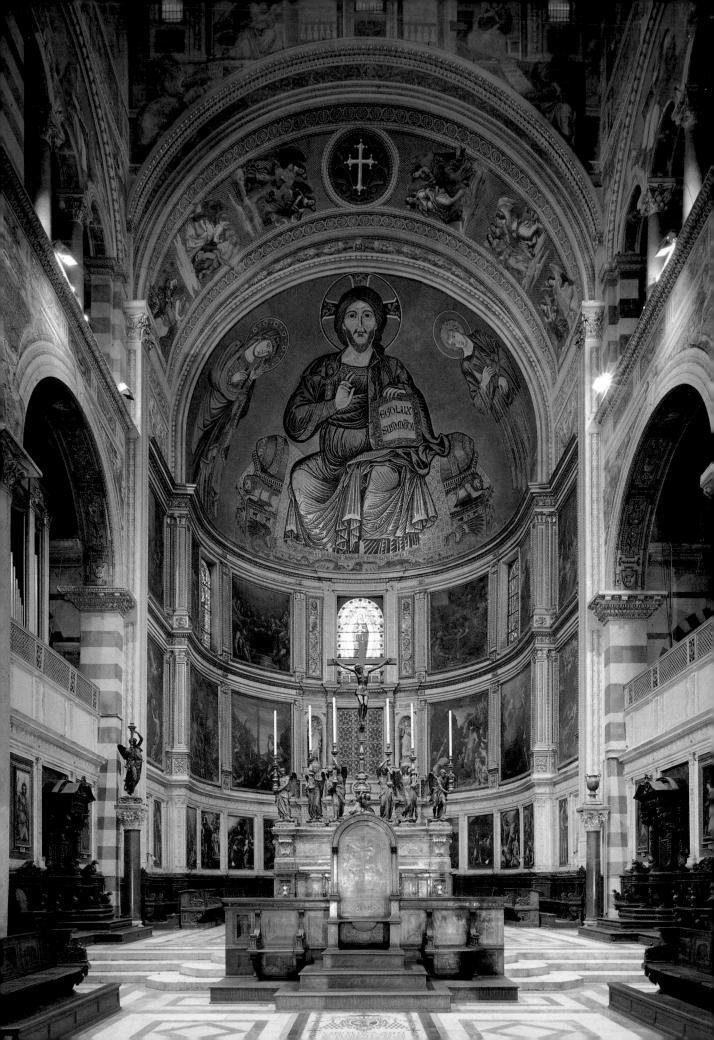

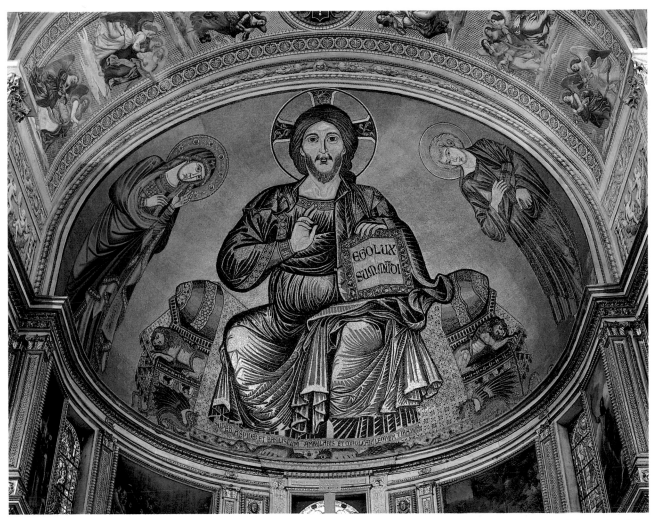

◄ The presbytery of the Cathedral with the high altar and the magnificent decorated apse.

A detail of the mosaic in the conch of the apse (Christ flanked by St. John the Evangelist and the Madonna).

masterpieces of Pisan 14th-century sculpture. The reliefs (executed between 1302 and 1310) depict *Scenes from the New Testament, Infancy and Passion of Christ, The Last Judgement.* The various panels are separated by figures of *Prophets* and *Sibyls.* The lower part of the pulpit symbolizes the *Doctrinal Principles of the Church.*

Upon entering the right-hand portion of the transept, near the first altar on the same side (a 16th-cent. work by Stagi) is a *Madonna and Child with Saints* of the same period by G. B. Sogliani and Perin del Vaga. Other paintings after the altar, on the right, are the *Liberation of an Obsessed Woman* (D. Muratori, 18th cent.); the *Vestition of S. Ranieri* (Benedetto Luti, 18th cent.). At the end of the transept is the *Chapel of Saint Ranieri,* built on the site of a previous chapel dedicated to the *Madonna Incoronata.* The venerated relics of the patron saint of Pisa are preserved in a Baroque urn in green marble, enriched by bronze ornaments and made by G. B. Foggini (17th cent.). On the left, next to the altar, is the *Tomb of Henry VII,* with the reclining statue of the emperor who for the Pisans and for Dante himself was the incarnation of the dream of Ghibelline rebirth. This tomb is one of Tino di Ca-

maino's finest works (14th cent.). Before reaching the Porta di S. Ranieri is a painting by Felice Torelli (18th cent.) which depicts *St. Ranieri Resuscitating a Young Boy.* On the other side of the door is a fine Renaissance altar by Fancelli (16th cent.) and S. Stagi.

Around the corner on the right is a fresco by G. B. Tempesti (*Last Supper,* 18th cent.). Above a small altar is a 17th-century *Crucifix* by Giovanni Bilivert. Near the baluster which encloses the high altar are two *Candelabrum Angels,* fine works in bronze (16th-17th cent.) by artists of the circle of Giambologna. Among the works of art which enrich the part in front of the high altar reserved for the clergy (presbytery) mention must be made of a *Saint Agnes* by Andrea del Sarto, who also painted the canvases depicting *St. Margaret* and *St. Catherine,* and a *Crucifix* in bronze on the altar (Giambologna). In the underside of the arch of the apse are fine works by D. Ghirlandaio (15th cent.) while the conch in the apse contains an imposing gold-ground mosaic showing *Christ between St. John the Evangelist and the Madonna.* It is a widely held opinion that Cimabue helped in realizing the figure of the Evangelist. The numerous paintings below the mosaic include works by Beccafumi, Sodoma (*Descent from the Cross,*

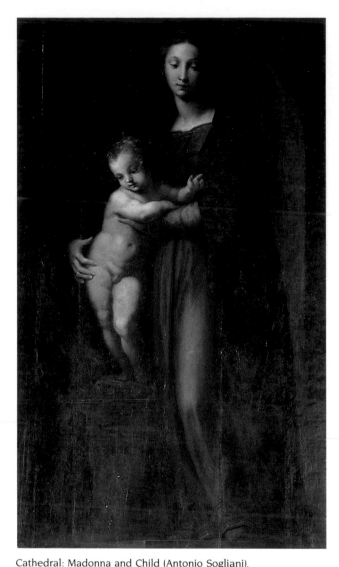

Cathedral: Madonna and Child (Antonio Sogliani).

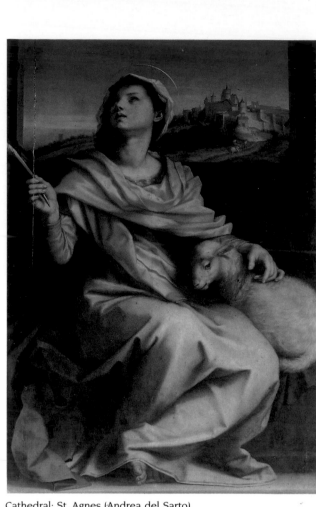

Cathedral: St. Agnes (Andrea del Sarto).

The Chapel of San Ranieri seen from the women's ▶ galleries.

The marble urn containing the mortal remains of ▶ St. Ranieri Scacceri, the Patron Saint of Pisa.

Cathedral: the Chapel of the Sacrament. ▶

Interior of the Cathedral facing the left transept. ▶

Sacrifice of Abraham), Lomi, Riminaldi and Vannini. Recently (1988) studies conducted by Giampiero Lucchesi have brought to light various frescoes painted in the first half of the 16th century (Giovanmaria di Ser Giovanni Tolexani and Ghirardo di Paolo del Ninna). On the northern flank of the presbytery are two paintings by Andrea del Sarto *(St. Peter* and *St. John)* and a *Madonna and Child* by Perin del Vaga. On the left of the high altar is a 16th-century altar with the painting of the venerated *Madonna di Sotto gli Organi* (13th cent.). There is also a *Nativity of the Virgin,* by Corrado Giaquinto (18th cent.).
The left transept, at the end of which is the rich *Cappella del Sacramento* (bronze and silver ciborium by G. B. Foggini, 17th cent.) with numerous canvases by Lomi *(Circumcision, Adoration of the Magi, Birth of Christ,* 16th cent.), a 17th-century painting by Pietro Sorri *(Christ Disputing with the Doctors),* a painting by Passignano (Domenico Cresti, 16th cent.) who painted the *Madonna and Child,* sculpture by Fancelli (17th cent.) and Moschino (Francesco Mosca, 16th cent.). The last altar, before the nave, has a painting by A. Lomi which

represents *Christ Restoring his Sight to a Blind Man.* The first altar on the right, moving from the transept towards the main exit, has a lunette with a 16th-century bas-relief of the *Apparition of the Madonna to S. Ranieri.* Next to the altar are two 18th-century paintings depicting the *Martyrdom of S. Torpè* (Placido Costanzi, G. B. Tempesti) and the *Discovery of the Head of S. Torpè* (G. B. Cignaroli). The *altar of the Angels* with a 17th-century depiction of *God the Father in Glory,* by V. Salimbeni follows. Two paintings to be admired between the altars are the *Baptism of Lambert, Son of the King of the Balearic Isles* (Lorenzo Pecheux, 18th cent.) and the *Blessed Balduino Reproving the Judge of Arborea* (Giuseppe Collignon, 19th cent.). On the third altar is a 17th-century canvas attributed to Passignano *(Holy Spirit and Martyrs,* 17th cent.). Then come two paintings: *The Blessed Domenico Vernagalli Founds the Foundling Hospital* (Gaetano Gandolfi, 18th cent.), *Martyrdom of the Blessed Signoretto Agliata* (Pietro Benvenuti, 19th cent.). On the next altar is a canvas by the 16th-century artist G. B. Poggi *(Founding Saints of the Religious Orders).*

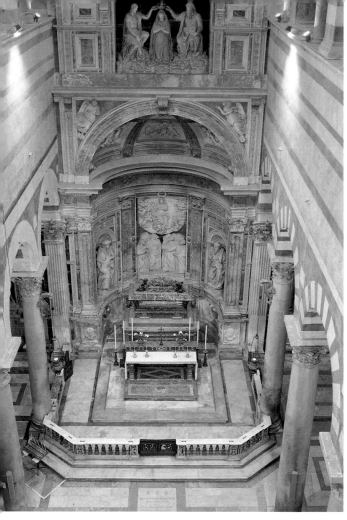

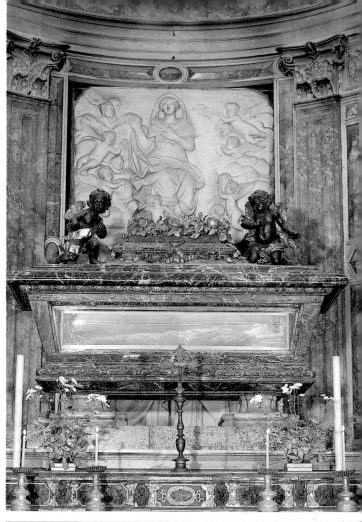

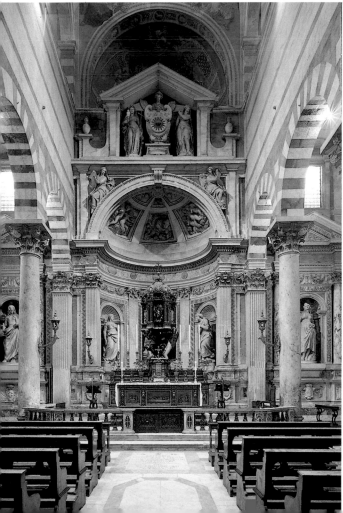

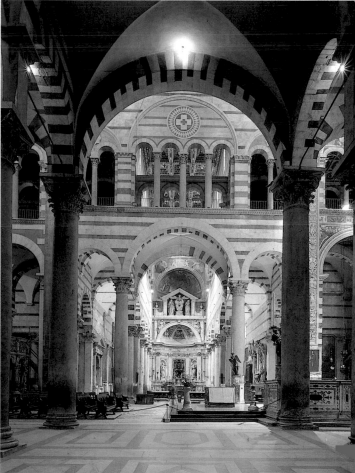

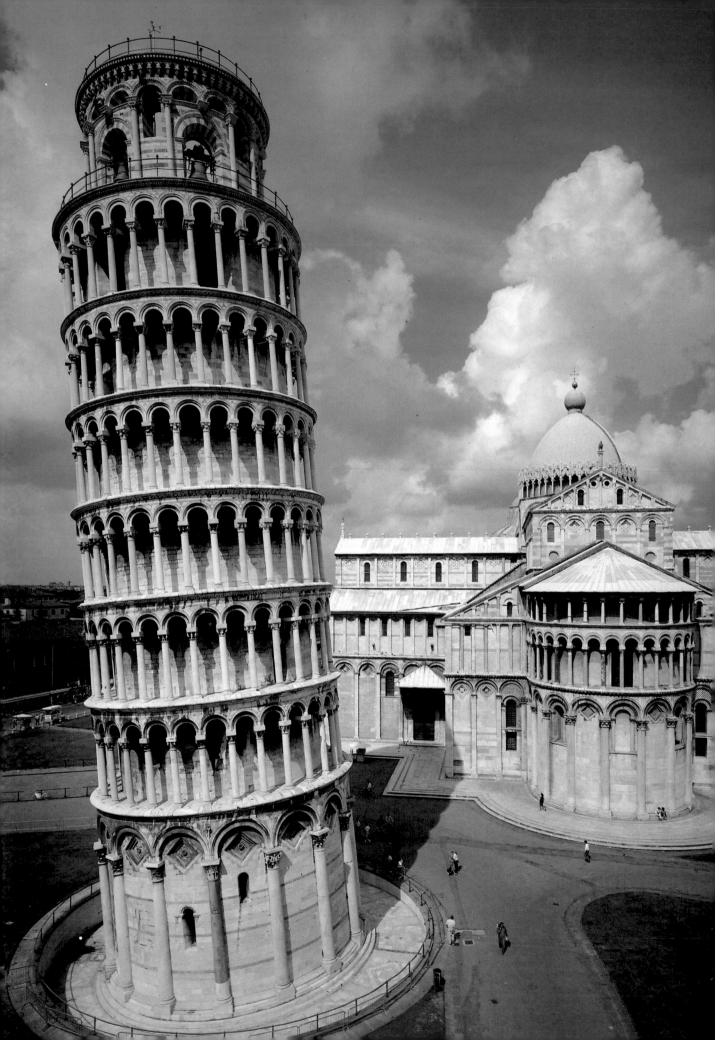

LEANING TOWER, HISTORY AND MONUMENT

The historical vicissitudes of the largest and most famous of the bell towers of Pisa still has many obscure points, uncertainties and doubts which the scarsity of official documents makes all the more difficult to solve. The first stone was laid on August 9, 1173, as confirmed by the inscription to the right of the entrance door. The construction of one of the most singular monuments of all times was thus begun, and its story — even up to our times — seems to be the stuff novels are made of. The building of the Tower, but above all its completion, represents the final link in the achievement of that imposing celebrative ensemble of monuments which are an integral part of the *Piazza dei Miracoli*.

Those who had commissioned the work intended them (Cathedral, Baptistery, Campanile, Camposanto Monumentale) to stand as a synthesis of the high level of splendor and power achieved by the Maritime Republic and with their astonishing marble fretwork and intarsias remain a sign for posterity of the indiscutable preeminence achieved by the Pisan galleys on the Tyrrhenian Sea and the coasts of the Near East.

The lack of specific inscriptions and documentary references leave doubt first of all as to who actually designed the Tower. Tradition attributes the merit to Bonanno Pisano, with the aid of Guglielmo da Innsbruck, but the hypothesis advanced by recent critics, assigning it to Diotisalvi, is not to be dismissed. According to Vasari, lastly, Nicola Pisano and in particular his son Giovanni may also have been involved in the vicissitudes of the largest of the Pisan towers, not perhaps in the project itself (a question of date) but in following the course of work and in studying the singular static behaviour. In any case, apart from the true identity of the designer, particular merit must be acknowledged to whoever initially began work on the campanile, demonstrating great technical skill and a good dose of courage. It should in fact be kept in mind that the foundations of the imposing structure were set at a depth of less than three meters on a pile of dry masonry. Whatever the case, the actual construction, begun in 1174, must have been suspended at the completion of the third ring, around ten years later, since a subsidence of the soil of between 30 and 40 cm. had thrown the tower out of the perpendicular, causing an initial overhang of circa five cm.

The theory that the Pisan Campanile was planned as leaning is therefore to be discarded as unfounded. Actually, according to Prof. Piero Pierotti, architectural historian, the use of construction material of considerable weight and the functional characteristics resulting from the staircase, which made it impossible to diminish the thickness of the masonry the higher one went, determined the subsidence of the foundations of the campanile, which rest on subsoil of alluvial nature, fairly compact on the surface but tending to subside at a depth. In the 19th century the singular inclination of the Campanile of Pisa was the subject of heated debate between those who maintained that it had been built in line with traditional canons (and therefore obviously upright, as was indeed the case) and those who were convinced that the Tower of Pisa had deliberately been made to lean, almost in defiance of common sense and the laws of physics, perhaps in the subtle intent of astounding and mystifying posterity. It should be specified in any case that the characteristics of the ground on which the campanile stands would allow for a load of one kilogram per square centimeter, while in effect the imposing marble structure forces it to support a weight ten times as great. Another factor which may have counseled the builders to use a circular form should not be overlooked — that of safety. It is in fact well known that the corners of square buildings are in themselves an element of risk, especially in case of subsidence of the soil, and the first designers of the Campanile may well have taken this into consideration. One of the most curious anecdotes with reference to its inclination says that Giovanni (Guglielmo) da Innsbruck purposely designed it as leaning, in an attempt to take revenge on his own deformity (he was a hunchback), ideally and in effect transforming it in the work that he was carrying out. The fact, obviously unfounded, excited the fantasy of an 18th-century French author, a certain Max Lamberg, who wrote of the discovery of a plaque in the outskirts of the city with a Latin inscription which would have furnished the tale with credibility. Another more popular version, simpler but just as delightful, attributes the inclination of the Tower to a credit advanced by the builder. When he failed to receive all the money agreed upon when commissioned to construct the monument, he is said to have lost his temper and ordered the Tower (completed and straight) to follow him (which therefore made it lean).

More than a century after the laying of the foundation stone, work was once again begun (1275) by Giovanni di Simone, who added three more levels, correcting the axis of the Campanile. In 1284 the six stories of loggias were to all effects finished, bringing the height of the building to 48 m., and employing a technical expedient that was meant to diminish, at least optically, the effect of the inclination, accomplished by raising the galleries of the upper floors on that side. At the time the inclination of the Tower was more than 90 cm. The tormented vicissitudes of the Tower did not, as one might expect, greatly worry those who were involved in the construction and completion. The long intervals between building activity were dictated, most likely, by the need of letting the Campanile 'rest', but above all by letting both the foundations and the ground on which they rested settle down. In a certain sense it can be said that the subsidence of the soil and the consequent inclination had, on the whole, been foreseen. At the beginning of the 14th century the bells were placed at the sixth level, in the large opening still visible in the marble cylinder beyond the loggia. Between 1350 and 1372 Tommaso di Andrea Pisano (according to Vasari) terminated the installation of the belfry on the summit of the sixth order of loggias, increasing the correction of the axis, and thus diminishing the load on the side that was in inclination, which in the meanwhile had become fixed at 1.43 m.

◀ A fascinating picture of the Leaning Tower and the apse of the Cathedral.

41

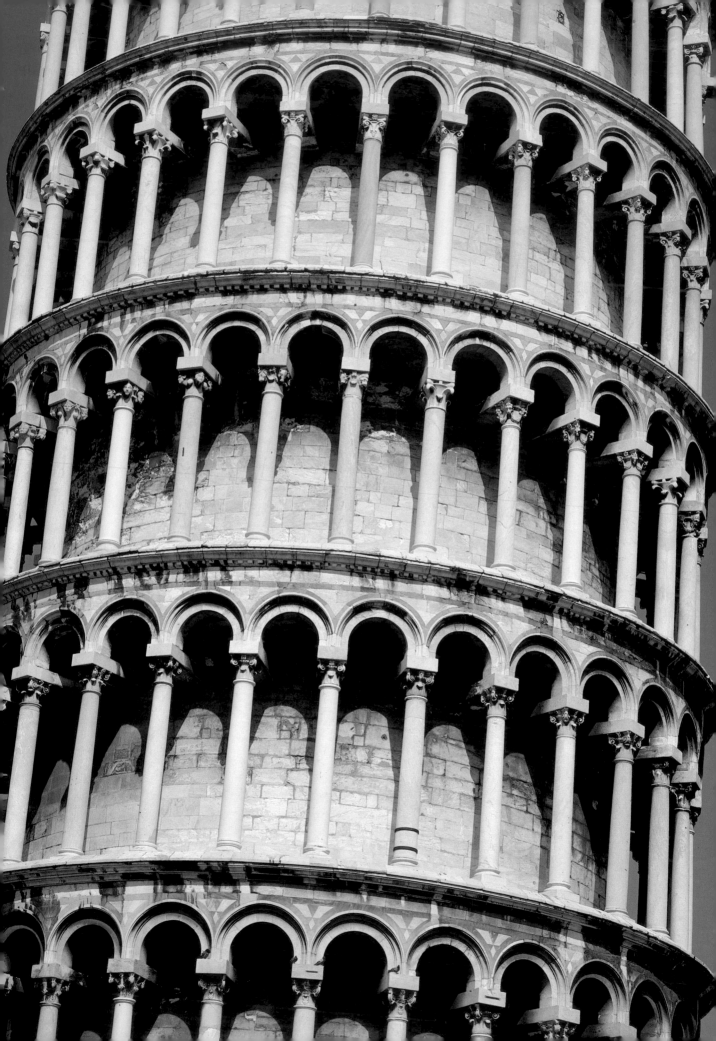

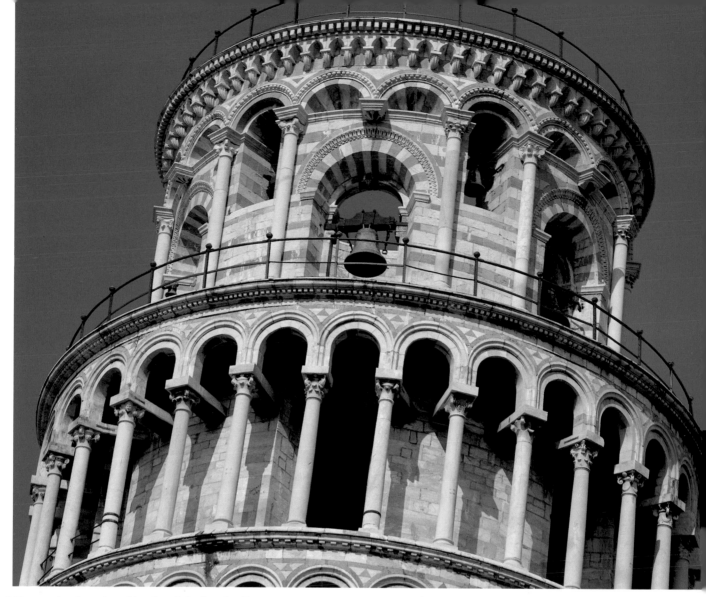

◄ The spectacular external loggias of the Leaning Tower wind around the masonry core.

The top part of the Leaning Tower with the belfry.

The problem of the inclination of the Tower, and consequently of its safeguarding, first appeared while it was still under construction. A first *Committee* of experts, composed of Giovanni Pisano, Guido di Giovanni and Orsello, was called in 1298. The first official measuring of the overhang dates to that period and was executed by Giovanni Pisano with cords and lead weights. The first alarm concerning the deterioration of various parts of the monument, in particular the columns, dates to 1396 and comes from a report drawn up by Maestro Lupo di Gante. In 1550, as stated by Vasari, the inclination of the tower was equal to six and a half arms (braccia) (3.79 m). Other surveys were undertaken by Schikardt (1599). From then on no new measurements were made until the 18th century: mention can be made of those of De la Condamine (1755), Soufflet (1758), Da Morrona (1787), De la Lande (1790). In 1817 the surveys by the English architects Edward Cresy and G. L. Taylor basically confirmed Vasari's measurements, ascertaining an overhang of 3.84

m, with an increase in inclination of barely 5 cm in 267 years. These data reveal that the campanile had unquestionably settled down and that stabilization had been consolidated. In 1838 Alessandro Gherardesca undertook various works which were to play an important part in the static structure of the Tower. The liberation of the base, up to then interred, the simultaneous demolition of a wall and a balustrade which fenced in the access, together with the construction of the marble basin raised the problem of the level of the water table at the base of the Campanile. An attempt to eliminate this flow of water was made, using expedients of questionable validity. The first data available after this date to 1859 when the French architect Georges Rohault de Fleury ascertained an increase in the inclination of all of 20 cm with regards to the previous measurements of Cresy and Taylor. In other words, from the works of Gherardesca to the surveys of De Fleury, the rate of overhang had increased by almost a centimeter a year. As an aside it might be

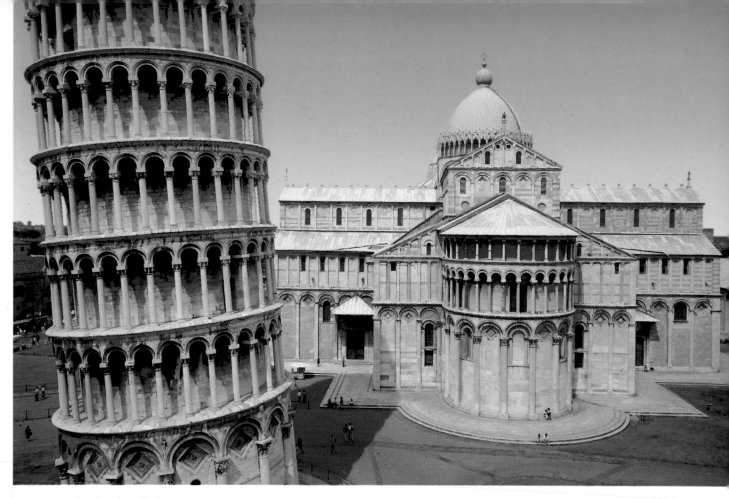

A detail of the cylindrical bearing structure of the Leaning Tower and the impressive external loggias facing the apse of the Cathedral.

conformity to the constructive synergies of the other monuments which make the *Piazza dei Miracoli* what it is. These architectural similarities, as well as the respect for proportions and distances, are evident in the height of the campanile which is equal to that of the dome of the Baptistery and the dome of the Cathedral. In terms of style, the Pisan Romanesque is an element of continuity with the other buildings in the most important religious center of the city, even if the cylindrical shape of the campanile recalls Islamic architecture and above all the models dear to the Byzantine architects of Ravenna.

THE VISIT OF THE TOWER

Singular *zoomorphic reliefs* flank either side of the entrance portal while the lunette above once contained a 15th-century *Madonna and Child* by Andrea Guardi (at present in the Museo dell'Opera del Duomo). Another relief depicts the *entrance to the Harbor of Pisa*, symbolized by a tower and two antique merchant ships. The entrance room to the Leaning Tower originally had no ceiling, allowing a view of the internal cylinder, open up to the top. An optical effect gave one the impression that it was straight and not leaning. For an idea of just how much the tower was off center, all one had to do was stand with one's feet, heels together,

against the northern wall of the entrance. The 'push' from behind exerted by the wall made it impossible to stay upright. The ropes which rang the bells also passed through the cylinder well before the bells were electrified. In 1935, when it was decided to set various control instruments in the Tower, the ceiling was constructed, cutting off the view of the interior.

Two plaques at the entrance to the monument recall the First Convention of Italian Scientists (held in Pisa in 1839 - on the plaque mention is made of Galileo's experiments from the Tower) and the discovery (1820) of fragments of a tomb and inscription with the name of Bonanno (now embedded in the entrance wall) which would seem to support the theory that he was buried at the foot of his 'creation'.

The staircase winds around the internal structure, shaped like an enormous cylindrical well, and leads to the external loggias, which have no protective railing. The panoramic terrace of the belfry is decorated by arcading, and smaller in size with respect to the allover cylindrical structure of the Tower. The names of the seven bells, electrified in the Sixties, are: *Assunta* (17th cent.), *Crocifisso* (newly cast in the 19th cent.), *Dal Pozzo* (17th cent.), *Pasquareccia* (13th cent.), *San Ranieri* (18th cent.), *Terza, Vespruccio*. It was from the top of this tower that Galileo carried out his famous experiments to determine the velocity of falling bodies by throwing down balls of different masses (1589).

A narrow stairway leads to the crowning of the belfry at

the very summit, providing a splendid view of the Cathedral ensemble and the square and the entire city, ranging from the mountains to the sea. Of interest is the fact that recent excavations in the vicinity of the Tower have brought to light the vestiges of an ancient Etruscan sanctuary of the 6th century B.C. and important remains of settlements dating to between the 5th and 4th centuries B.C.

MONITORING THE INCLINATION

To get back to our times, Bonanno's masterpiece has a real 'control exchange' which depends directly on the *Ministry of Public Works*. Sophisticated avantgarde instruments allow constant monitoring of the Campanile, transmitting simultaneously the data on the conditions to the competent offices of the *Civil Engineers* in *piazza dei Cavalieri*. In addition, every day the *Hydrographic Office of the Arno* checks the level of the water table by inspecting a small well in the *piazza del Duomo*. It has in fact been ascertained that a lowering of the water level aggravates the rate of inclination, while no damage is done to the monument if the water level remains stable or rises.

Lastly the *University Institute of Topography and Geodesy* carries out periodic measurements of the inclination of the Tower using a theodolite. Once done annually on a set date, these measurements are now effectuated every three months.

Foliage and singular animal figures decorate the capitals of the engaged columns at the base of the Leaning Tower. Lozenges with marble intarsias decorate the blind arcading.

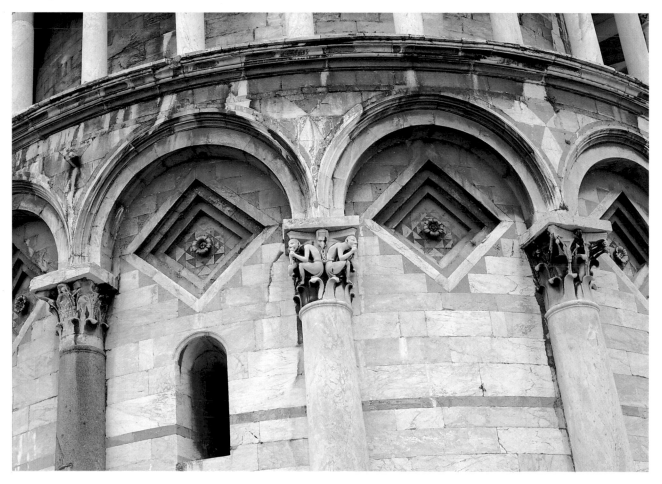

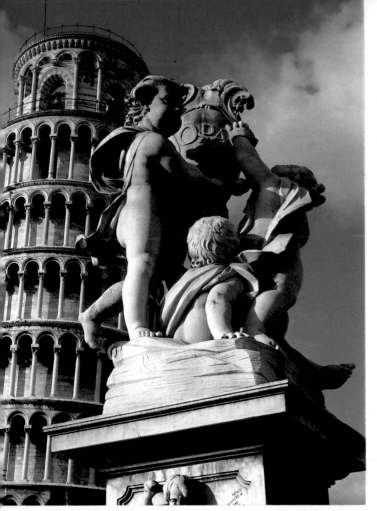

FONTANA DEI PUTTI

Originally the monumental fountain that we see today was nothing more than a public utility meant to satisfy the water needs for that part of the city. The base dates to the beginnings of this type of urban decoration, around the middle of the 17th century. In the times of the Operaio Quarantotti (18th cent.) it was decided to make the fountain higher and Vaccà was entrusted with making the sculptures after a design by Tempesti. The three *Putti holding the coat of arms of Pisa* have ever since constituted a charming decoration for the square. Originally the fountain was surrounded by an iron railing. The three marble children have, in the course of the centuries, run the risk of being replaced: in the latter half of the 19th century it was proposed to set a statue to Buscheto Pisano where they stand, while in the time of Cardinal Maffi (first half of the 20th cent.) it was suggested they be replaced by a statue to Galileo. In the summer of 1992 gesso fragments found in the storerooms of the Opera Primaziale Pisana were found to be similar to the Putti in their features and this was convalidated when the restorers recomposed them and confirmed the fact that what they had were the models used by the sculptor.

NEOATTIC VASE

The vase that stands on a base to one side of the apse of the Cathedral is a copy made by the sculptor Kufferle in the first half of the 20th century of the so-called *Vase of Talents*, in the Camposanto Monumentale. This marble vase dates to the 2nd century A.D. and is decorated with *Dionysiac figures* in bas-relief, inspiring artists such as Nicola Pisano for some of his panels in the pulpit in the Baptistery. The rather odd name of the vase is the result, according to an anecdote, of the fact that the Pisani had to put talents into it as payment of taxes. When Lasinio supervised the preservation of the works of art, it was decided to tranfer the original to the Camposanto Monumentale, with the twofold purpose of enhancing the monument and of safeguarding the Attic artefact from deterioration and weather.

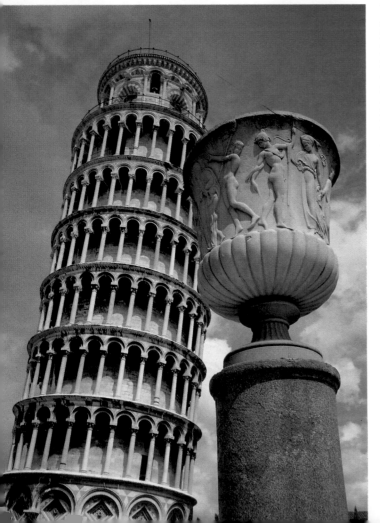

The 18th-century Fontana dei Putti with the Leaning Tower in the background.

A copy of the so-called 'Vase of Talents', a Neoattic original, with the Leaning Tower in the background.

View of the Piazza dei Miracoli with the Fontana dei ▶ Putti and the Leaning Tower.

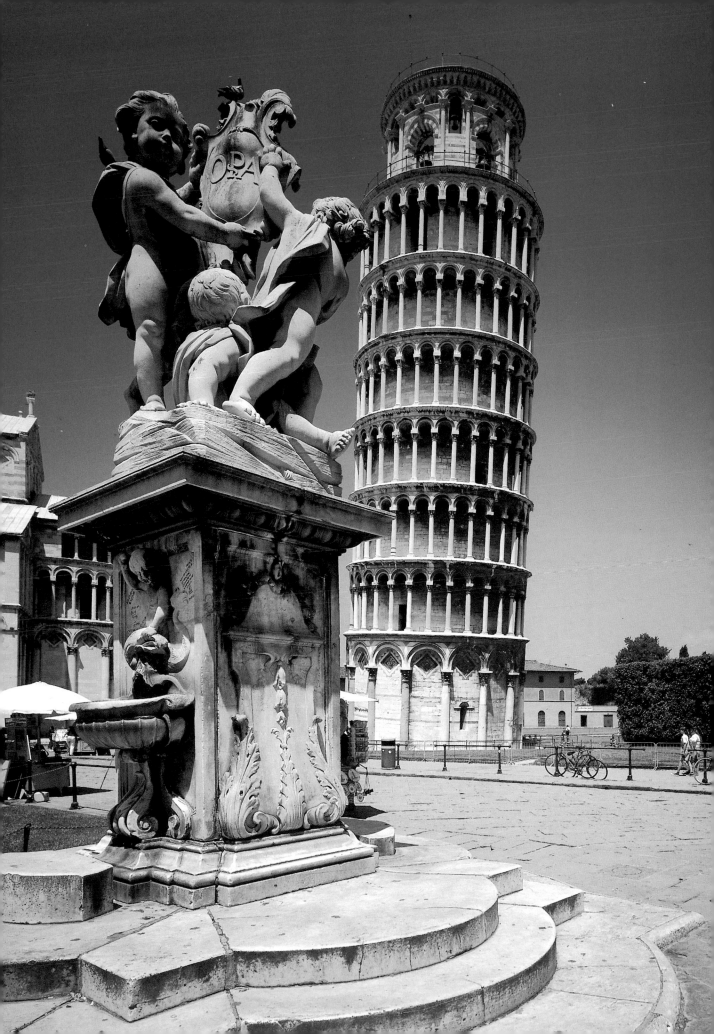

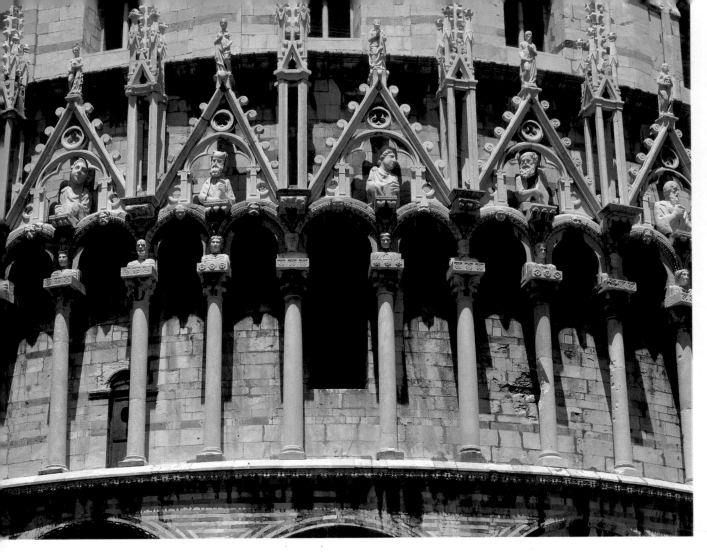

Baptistery: a detail of Nicola Pisano's splendid loggia, decorated with aediculas and a profusion of sculptured works and decorative elements.

An imposing and unique structure, the Baptistery seems ▶ to rise up out of the green of Piazza dei Miracoli.

BAPTISTERY

In size and aspect the Baptistery, an imposing construction with a circular ground plan and dedicated to *St. John the Baptist*, is, together with the Cathedral, the Tower and the Camposanto Monumentale, one of the focal points of the Piazza dei Miracoli. Construction was begun in 1152 by Diotisalvi in Romanesque style. It was continued about a century later by Nicola Pisano who added the airy loggia with its Gothic embroidery of triangles and aediculas, the setting for sculpture from the workshop of Nicola and Giovanni Pisano. The finishing touch to this marble gem is the dome, terminated in the 14th century, covered with tiles and lead plaques and crowned by a bronze figure of the *Baptist*, attributed to the 14th-century artist Turino di Sano. Of the four portals, the one on the east which opens onto the splendid facade of the Cathedral, is the finest and artistically most elaborate. The jambs are decorated with beautiful reliefs of pure Byzantine inspiration which depict, on the right, the *Apostles*, the *Ascension* and *David*, while on the left a trenchant series of the *Months*. The lintel is divided into two tiers; in the lower one is a description of *Episodes in the Life of St. John the Baptist*, in the upper one, *Christ between the Madonna and St. John the Baptist with Angels and Evangelists* alternating.

The lunette of the portal contains a copy of Giovanni Pisano's *Virgin and Child* (the original has been transferred to the Museo dell'Opera del Duomo). In front of the portal, on the pavement which leads to the Cathedral, a plaque recalls the Mass celebrated there by Pope Paul VI when he visited Pisa (June 1965). Pope John Paul II officiated at the holy celebration in the same place (September 1989).

The **interior** is characterized by a practicable gallery while the fine baptismal font (13th cent.) is the work of Guido Bigarelli from Como.

The most important work of art is the *Pulpit* (1260) by Nicola Pisano. Set on columns supported by lions, the wonderfully figured relief panels narrate *Episodes from the Life of Christ*. Behind the baptismal font is

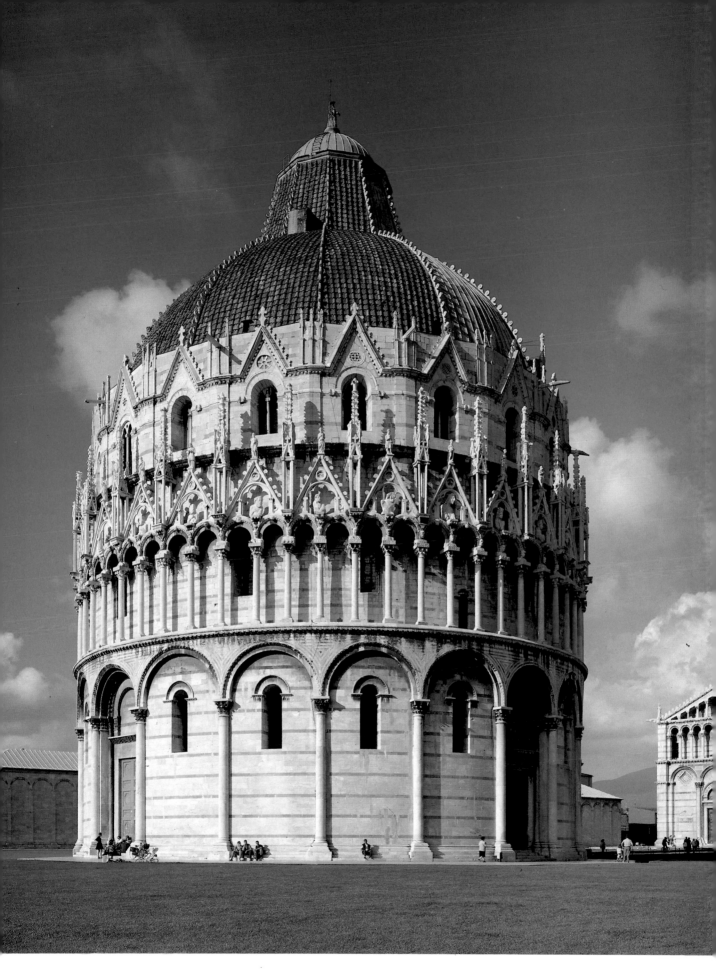

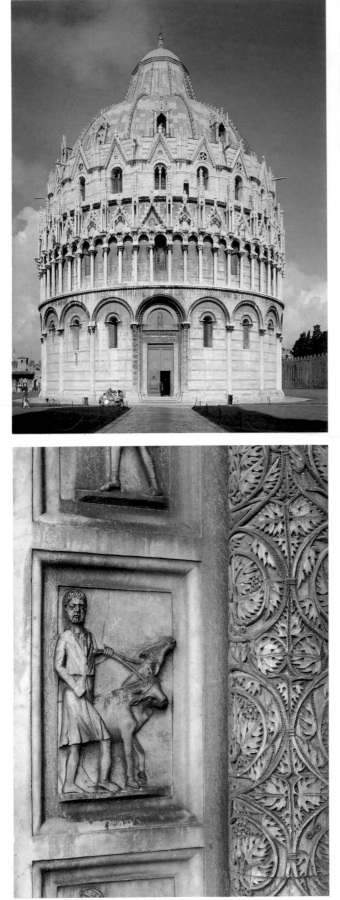

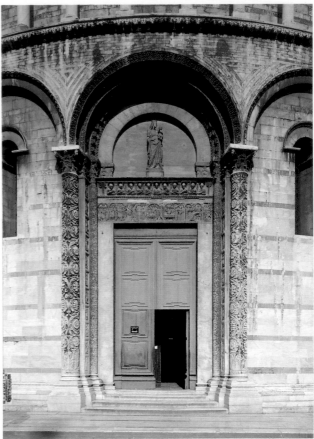

A view of the Baptistery; the splendid entrance portal and a detail of its sculptural decoration.

Baptistery: detail of the lintel of the entrance portal ▶ (Christ between the Madonna and St. John).

Baptistery: detail of the lintel of the entrance portal ▶ (Evangelist and Angel).

the altar, surrounded by the 17th-century choir stalls. It is decorated with 13th-century marble panels and stands on a Cosmati pavement of the same period. *Cosmati* work takes its name from the Cosma, a family of craftsmen who worked prevalently in Rome and Latium between the 12th and early 14th centuries, drawing inspiration from classic motives with strong Lombard and Siculo-Campanian influences. Their work is characterized by geometric motives in a mosaic technique, and is to be found particularly in cloisters, pulpits, ciboria, portals and pavements. Mention must also be made of the acoustical peculiarity of the building: a single sound generates a harmonious echo of various tones.

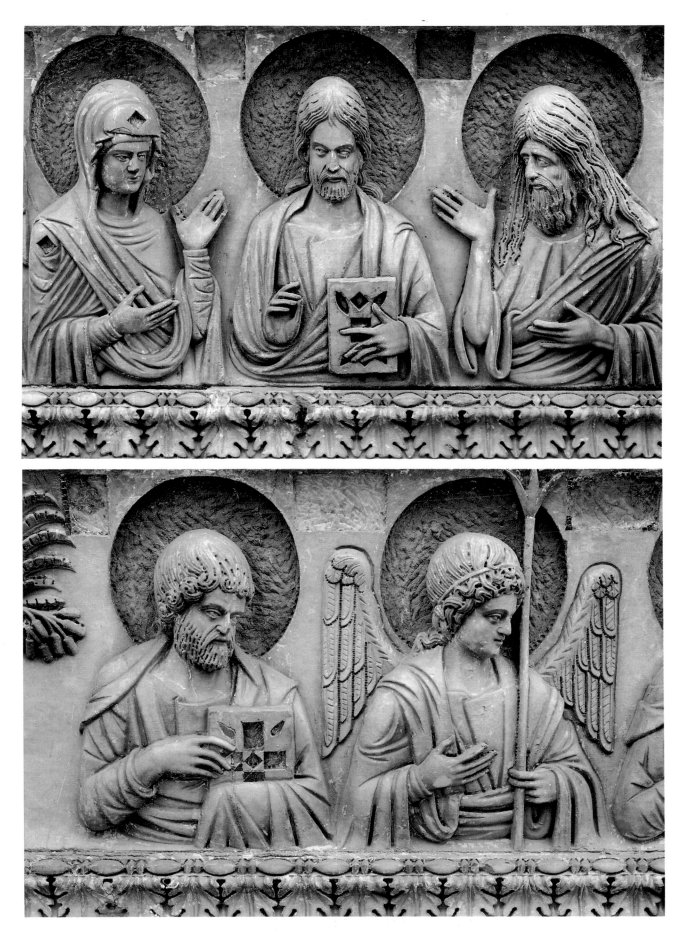

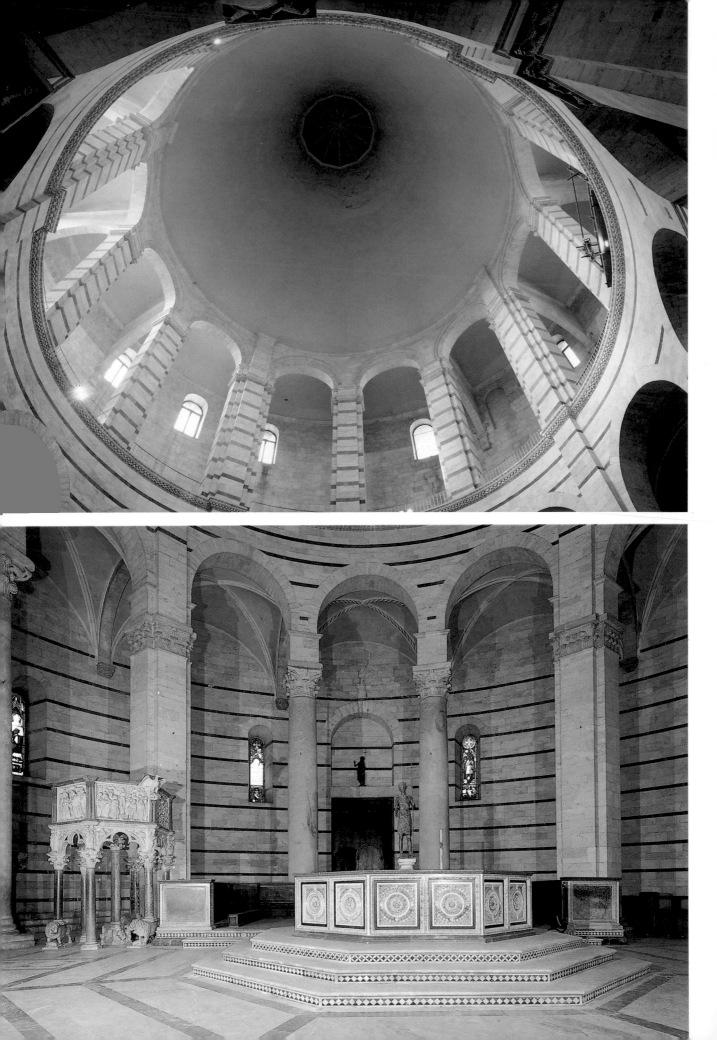

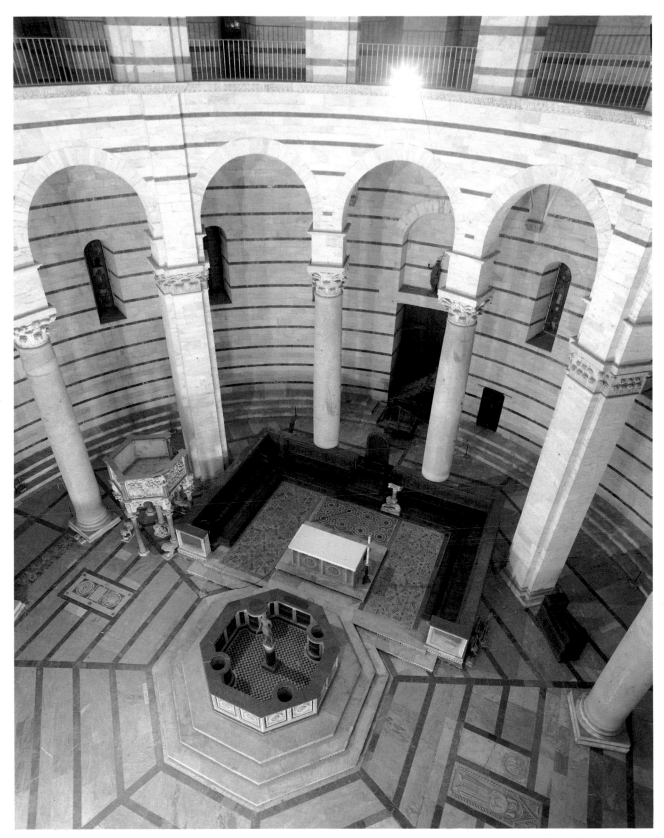

◄ Baptistery: view of the interior loggia and the dome.

◄ Interior of the Baptistery with the baptismal font and
Nicola Pisano's pulpit.

Interior of the Baptistery seen from the upper loggia.

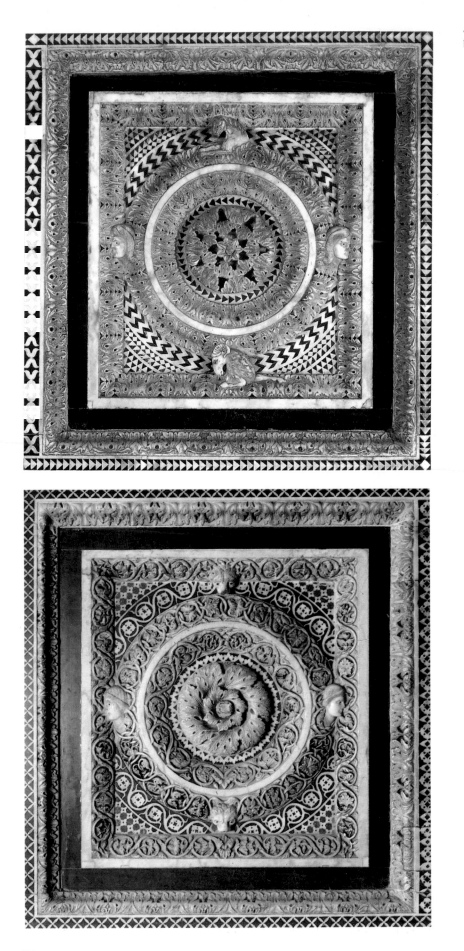

Two splendid marble panels on the balustrade of the baptismal font.

This picture and those that follow ▶ illustrate Nicola Pisano's outstanding hexagonal pulpit of 1260, an important example of the greatness of medieval Pisan sculpture, and which he signed with his name. This pulpit effectively synthesizes various concepts of the art of sculpture in Pisa in the Romanesque period, here obviously a celebrative eulogy of religious feeling. The general view shows us the architectural structure of Nicola's masterpiece, to which other famous artists of the time contributed individual sculptures. Among these were Nicola's son, Giovanni, and the great architect and sculptor from Colle Val d'Elsa, Arnolfo di Cambio. The airy structure of the pulpit rests on a central plinth decorated with zoomorphic and anthropomorphic sculptures, surrounded by columns, some of which are supported by lions. Trilobate arches spring from the columns; above is the series of panels which constitute the hexagonal parapet of the pulpit. A marble Eagle, one of the best known symbols of the Republic of Pisa, rises up above it all. The bas-reliefs, finely worked by Nicola Pisano and his capable collaborators, propose some of the most important episodes of Christology such as the Birth of Christ, the Annunciation, the Annunciation to the Shepherds, the Adoration of the Magi, the Presentation in the Temple, the Crucifixion, the Last Judgement.

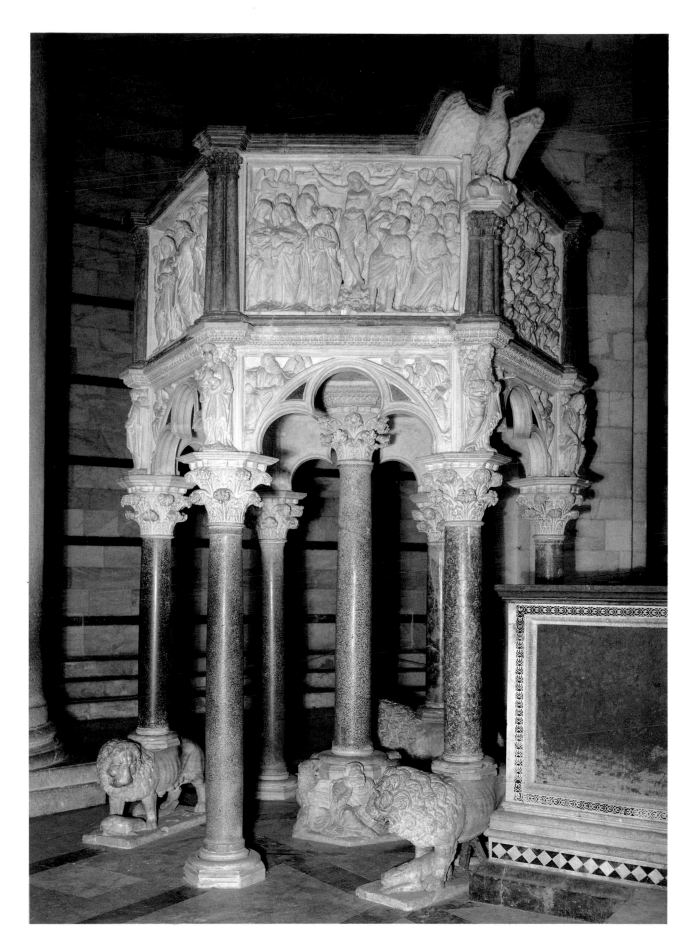

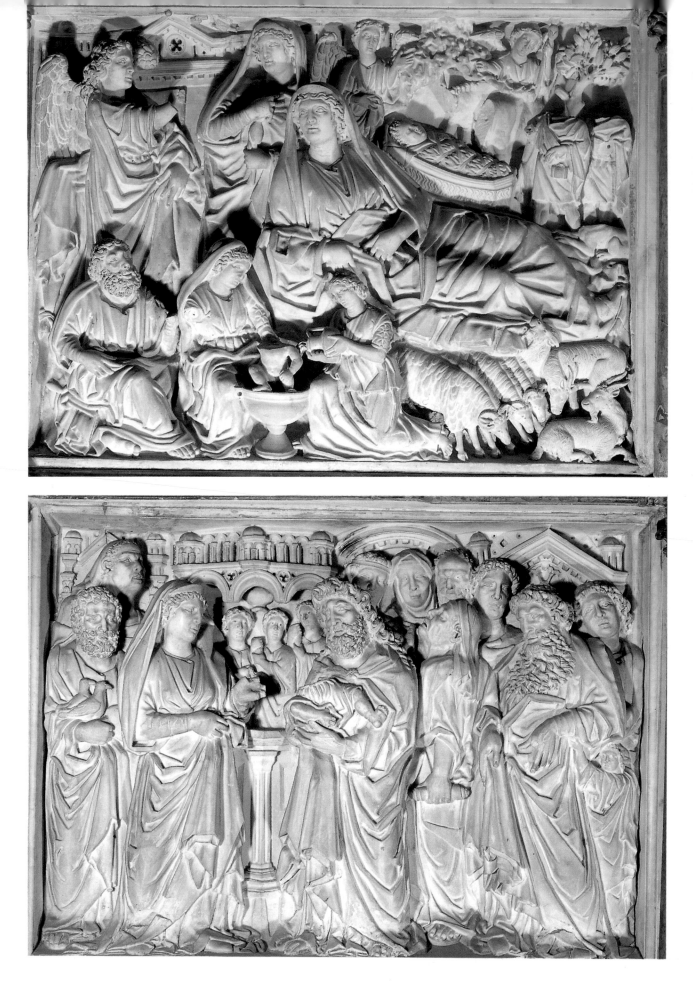

58

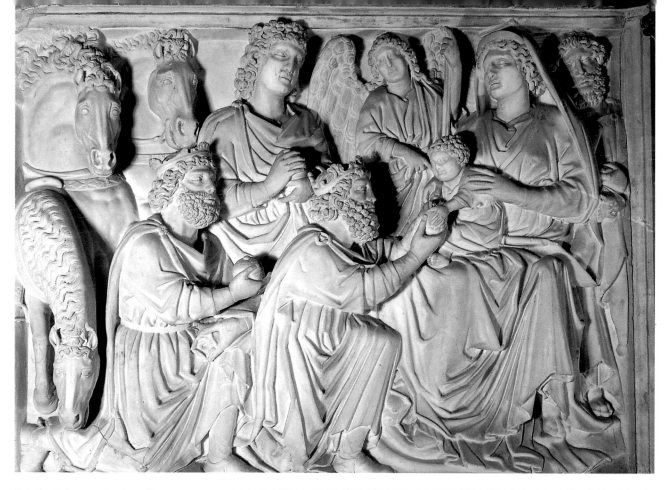

Details of the panels of Nicola Pisano's pulpit in the Baptistery illustrating episodes from the life of Jesus: the Annunciation and the Nativity; the Presentation in the Temple; the Adoration of the Magi; the Crucifixion.

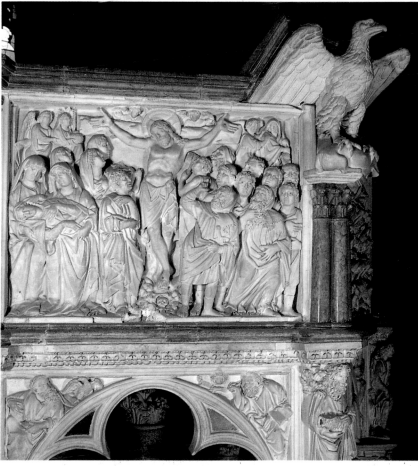

Museo dell'Opera del Duomo: one of the most
representative rooms where real masterpieces such as the
Burgundian Christ and the Fatimite Griffon are to be seen.

ings of the Cathedral, fragments and delicate intarsias
which survived the fire of 1595. These interesting re-
mains, datable to between the 15th and 16th cen-
turies, include parts of the chairs (note the allegorical
figures of *Faith, Hope, Charity* by Baccio and Piero
Pontelli), the remains of the sacristy Choir with intar-
sias by pupils of Cristoforo da Lendinara. Other ob-
jects not to be missed include two *'Exultets'* (12th-13th
cent.), parchment scrolls which the celebrant unrolled
from the ambo (pulpit with a lectern in the ancient
Christian basilicas) during the liturgy of Holy Saturday,
and some illuminated choir books of the 14th-15th
centuries.

Church vestments from the cathedral are to be found
in **Rooms XVII-XX**. Most of them date to after the fire
to 1595. The ecclesiastical paraments and liturgic vest-
ments, which include examples of Spanish and French
make, Florentine velvets, embroideries in gilded silver
and neoclassic paraments form a separate category.
In **Rooms XXI-XXV** the engravings and watercolors by
Carlo Lasinio (19th cent.) are on exhibit. As curator of the
Camposanto Monumentale, he devoted himself to co-
pying the wall frescoes. Merit for the archaeological col-
lection, which includes Egyptian, Etruscan and Roman
antiquities, must also go to Lasinio. The museum also in-
cludes two rooms for temporary exhibitions.

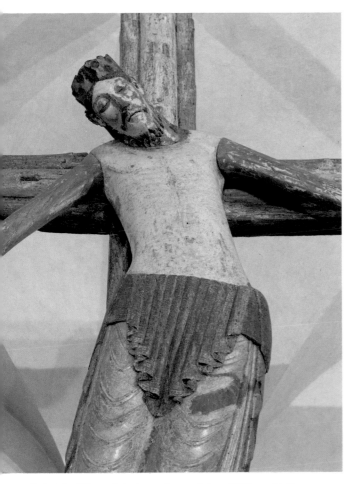

A detail of the painted wooden sculpture (12th cent.), the work of Burgundian artists following Byzantine models. The 13th-century Pisan school of painting was directly inspired by the prototype of the painted Crosses. Giunta Pisano of Capitino was one of the most representative artists of this style. These Crucifixes painted on panel became the stereotype for a fertile production which included works by Giunta and Berlinghiero (examples in the Museo Nazionale di S. Matteo) and Enrico di Tedice (Crucifix in the Church of S. Martino). The bronze Griffon, of which a detail is shown, is a masterpiece of Islamic 11th-century art. This symbolic animal, thought to have auspicious qualities, decorated the summit of the apse of the Cathedral until the latter part of the 1920s, when it was replaced by a copy.

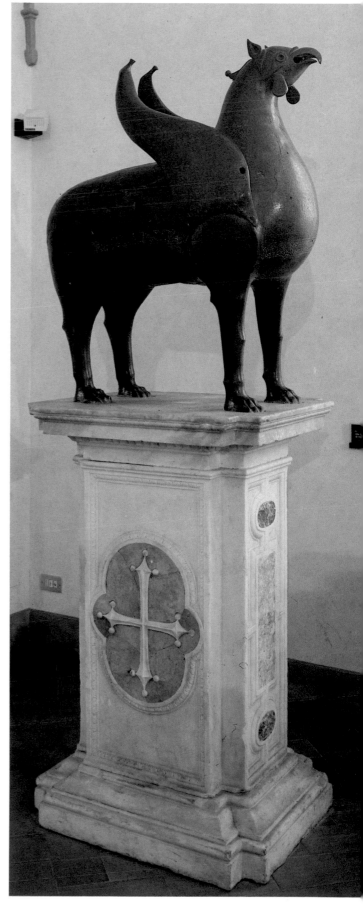

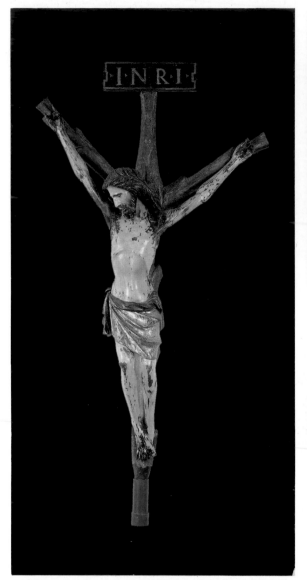

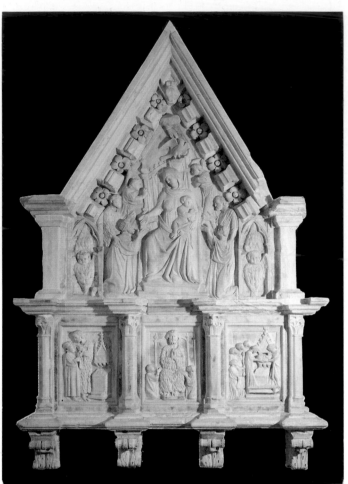

Museo dell'Opera del Duomo: the altar-tomb of Saint Ranieri (Tino di Camaino).

Museo dell'Opera del Duomo: the wooden Christ, better known as the 'Elci Crucifix' (Giovanni Pisano).

Museo dell'Opera del Duomo: sculptured figures of Henry VII and his councilors (Tino di Camaino).

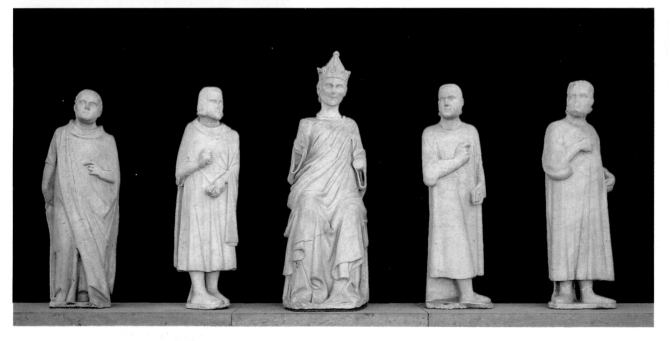

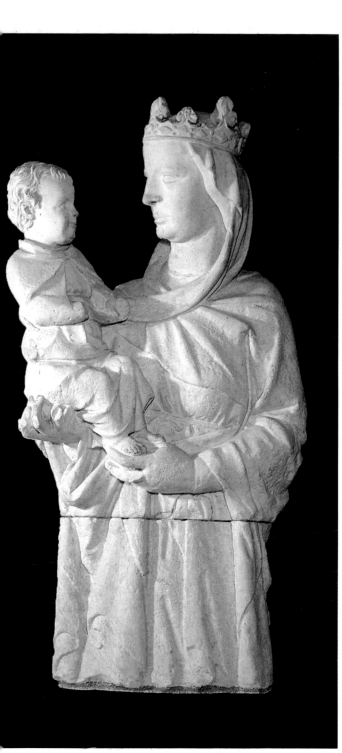

Museo dell'Opera del Duomo: the Madonna del Colloquio
(Giovanni Pisano).

Museo dell'Opera del Duomo: Madonna and Child, in ivory
(Giovanni Pisano).

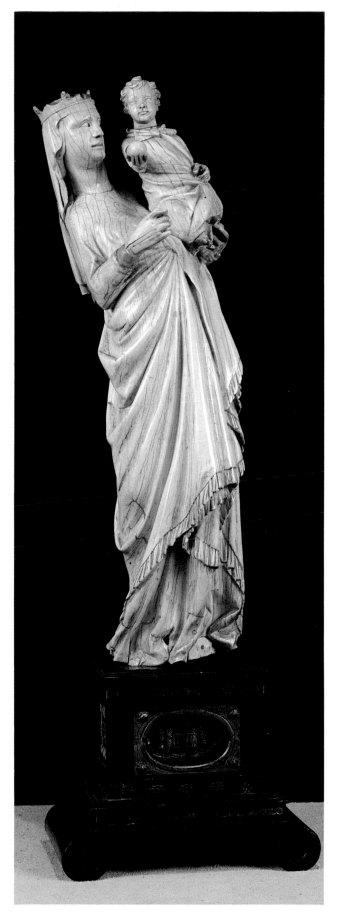

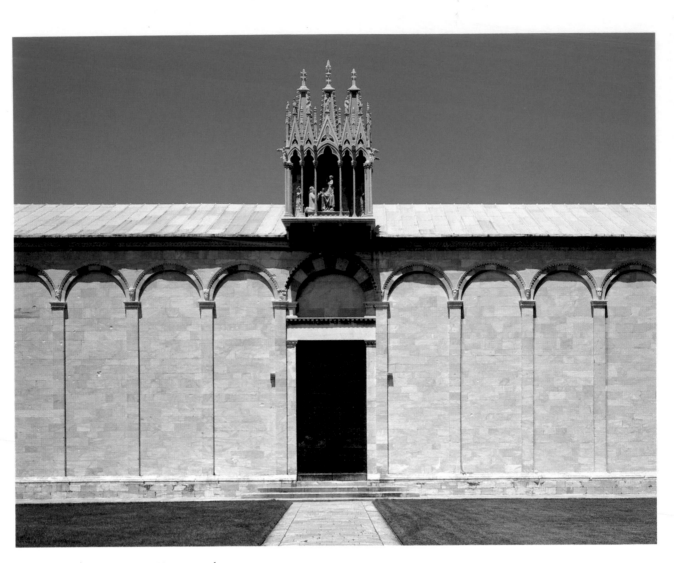

Entrance to the Camposanto Monumentale.

CAMPOSANTO MONUMENTALE

In its candour, the building forms an outstanding backdrop for the inspiring stage setting of the *Piazza dei Miracoli.* The elongated **facade** which faces the square is built of regular limestone ashlars, ornamented by slightly projecting pilaster strips which support the elegant row of blind arcading. The entrance on the right is surmounted by a splendid Gothic tabernacle, enriched by tracery and pinnacles and with a sculptural group of the *Virgin and Child with Saints and a kneeling figure,* thought to be the work of artists of the circle of Giovanni Pisano (14th cent.). Construction of the Camposanto, which in its size and in the unique placement of the architecture resembles a great unroofed basilica, was begun in 1278 by Giovanni di Simone. It is traditionally said that the earth in the center of the spacious cloister was brought from the Holy Land by the Pisan galleys, commanded by Archbishop Lanfranchi, after the Crusade of 1200. Construction, apparently continued in the 14th century under the direction of Lupo di Francesco, seems to have been terminated in the latter half of the 15th century. In 1593 Archbishop Dal Pozzo had the Renaissance chapel of the same name, and crowned by a dome, built.

Unfortunately the fire that resulted from the explosion of a shell (27-7-1944) seriously damaged the building and its works of art. As much as possible has been salvaged and in part restored to its original splendor, although the work is by no means finished.

The wealth of objects that testify to the past include numerous Roman sarcophaguses (1st-3rd cent. A.D.), reused in medieval times as was often the custom at the time; a considerable number of well tombs *(tombe a pozzetto)* sealed with marble funerary inscriptions (circa 600); and by epigraphic documents, tombstones, frescoes and funerary monuments of varying periods.

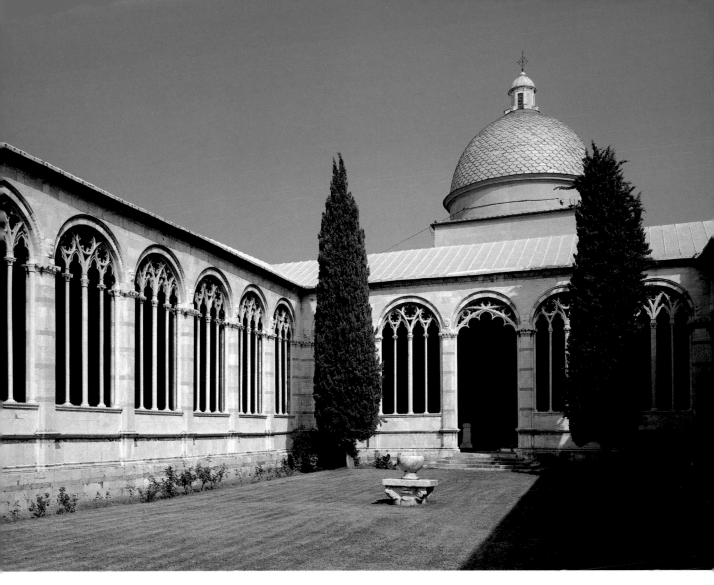

An evocative view of the inner courtyard of the Camposanto Monumentale with the dome of the Dal Pozzo Chapel.

On the following pages: unusual view of the Camposanto Monumentale with the Cathedral.

In the **South Gallery** the fresco paintings by the Florentine Taddeo Gaddi depicting the *Stories of Job* (14th cent.) are remarkable. Of note also the rich *tomb of Francesco Algarotti* (18th cent.). The oval marble object to be seen upon entering the **West Gallery** is a Roman sarcophagus (3rd cent. A.D.). Somewhat further on, above, hang the chains which closed the access to the harbor of Pisa and which were carried off by the Genoese in 1362. The trophy, which was in Florentine hands for a long time after the city had received it as a gift from Genoa, was returned in 1848. Of the numerous *tombs*, mention should be made of that of *Bartolomeo Medici,* commonly attributed to Tribolo (16th cent.). Recent reorganization has once more put various works in their original location, including the fresco paintings by Lomi, Ghirlandaio and Guidotti (16th-17th cent.) and the *tombs of Francesco Vegio* (16th cent.) and *Anastasia Schouvaloff* (19th cent.). The 14th-century frescoes of Umbrian school, depicting *Episodes from Genesis,* are to be seen in the **North Gallery.** On the pavement are funerary inscriptions of famous contemporary Pisans, who distinguished themselves particularly in the sciences. The *Cappella Ammannati,*

with the *tomb of Ligo Ammannati* once more in its original place, comes next, and then on to the hall, an achievement of the early Fifties, where important detached frescoes from the South Gallery are on display. These vigorous 14th-century interpretations, of uncertain attribution (Traini, Orcagna, Buffalmacco or an unknown artist of the Po basin) depict the *Crucifixion,* the *Triumph of Death,* the *Last Judgement* and *Hell.* Another fresco of the same period shows the *Stories of the Anchorites.* A second hall (photographic reproductions of the frescoes) contains a Greek vase in marble (2nd cent. A.D.) with *Dionysiac scenes* in low relief. Once more in the North Gallery, there is a charming Roman sarcophagus with the story of the *Myth of Phaedra* (2nd cent. A.D.). The 14th-century *Cappella Aulla* contains a fine polychrome terracotta attributed to Giovanni della Robbia (16th cent.). The walls right outside the chapel were once adorned with splendid frescoes by Benozzo Gozzoli *(Old Testament stories).* Atmospheric agents and the war were responsible for their deterioration and the surviving parts have been detached. The *sarcophagus with the Muses* can however be seen. With reclining figures and niches filled

67

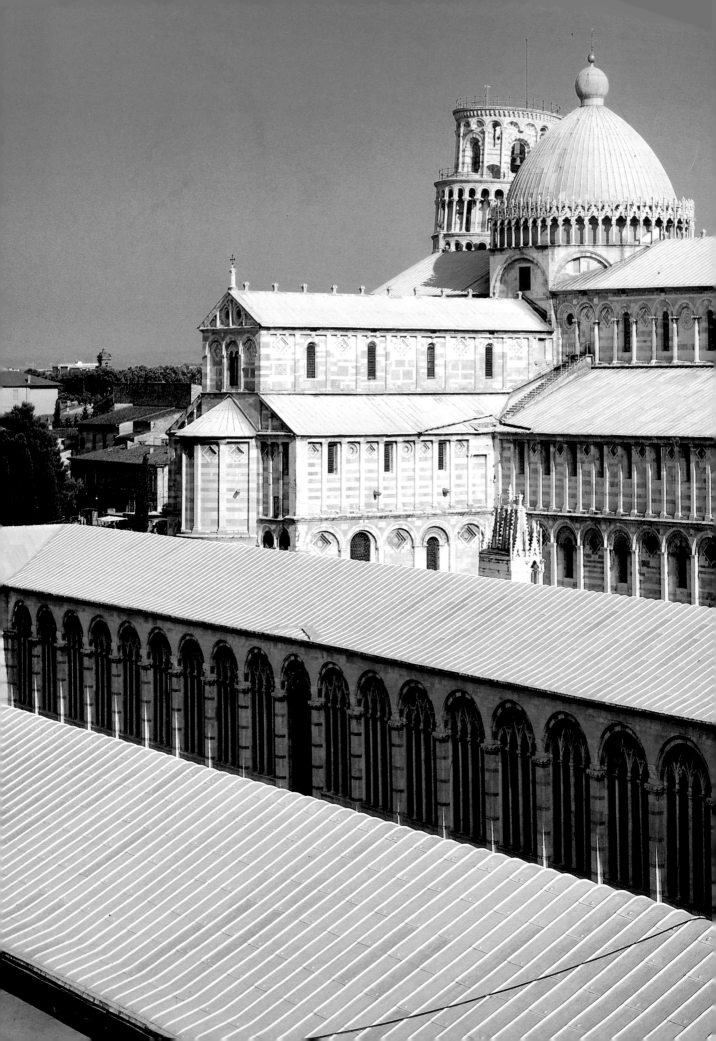

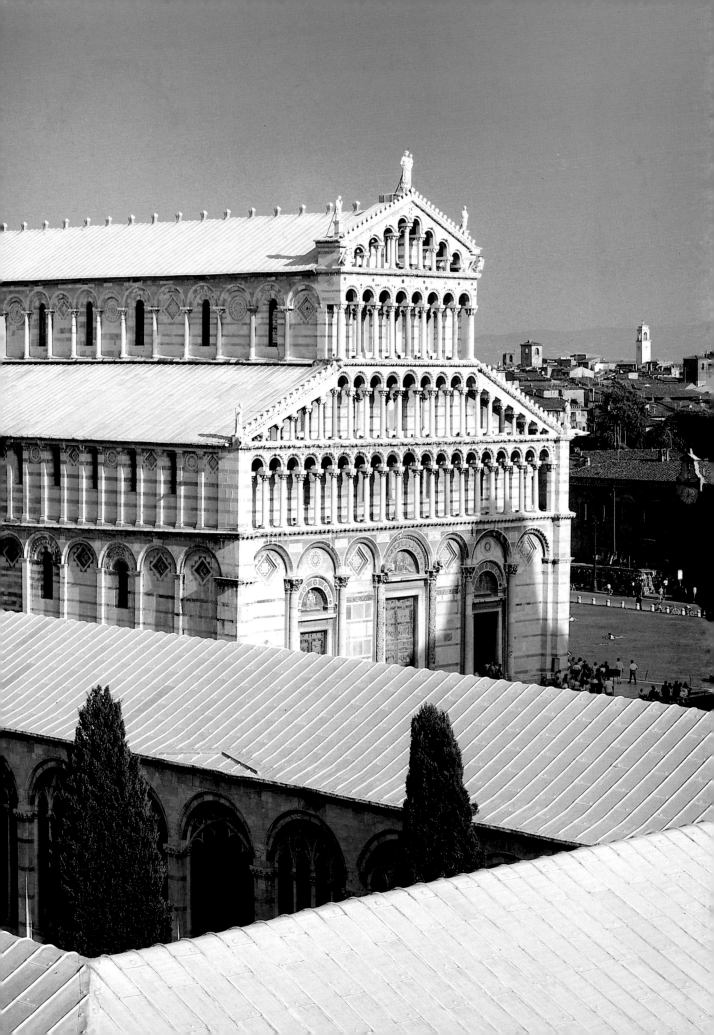

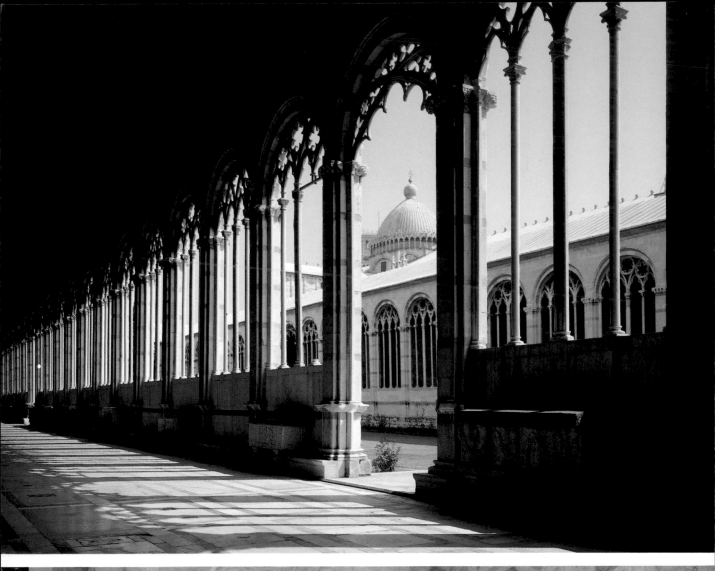

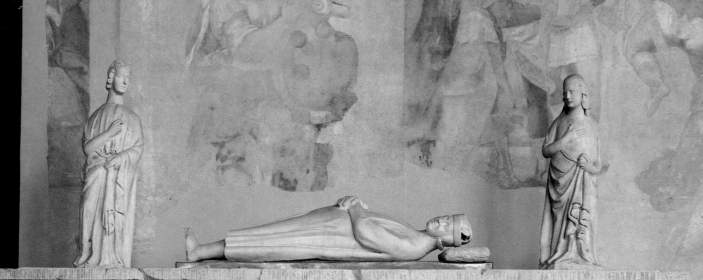

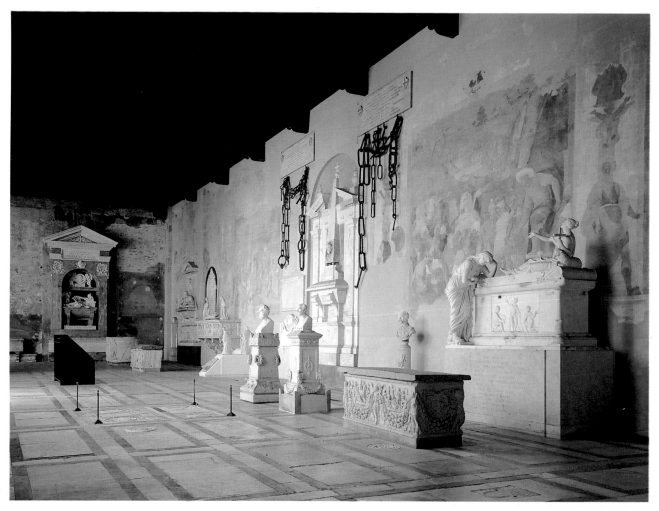

The North Gallery of the Camposanto Monumentale, enriched by sarcophaguses, sculptures and frescoes.

North Gallery: the Tomb of Bartolomeo Medici (Tribolo) and the chains of the Harbor of Pisa given back by Genoa.

◄ View of the North Gallery of the Camposanto Monumentale.

◄ Camposanto Monumentale: the Gherardesca tomb (attributed to Tommaso Pisano).

with splendid bas-reliefs, it dates to the Empire (3rd cent. A.D.). In the **East Gallery** various funeral monuments have found a worthy home: of particular note those by Lorenzo Bartolini, Giovanni Duprè and Stagio Stagi. The stately *funeral monument of Boncompagni* (16th cent.) was executed by Ammannati, who also did the figures of *Justice, Peace* and the *Redeemer*. Beyond the *Cappella Dal Pozzo*, the South Gallery houses various *tombstones* of Roman date (1st cent. A.D.). The detached frescoes from the wall of the North Gallery are at present being restored, including the trenchant fragmentary excerpts of Gozzoli's 15th-century frescoes, the scenes from the *lives of Saints Ephysius and Potitus*, by Spinello Aretino, and the *Stories of St. Ranieri* frescoed by Veneziano and Buonaiuti.

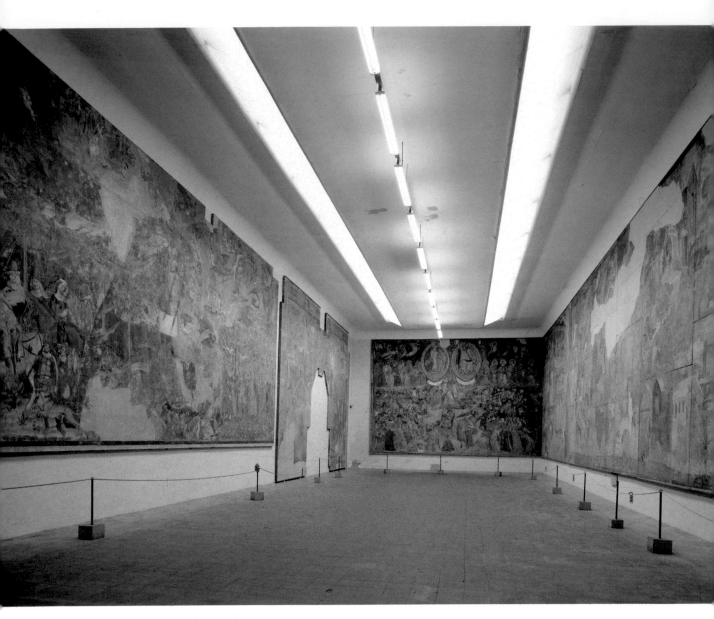

Camposanto Monumentale: Salone degli Affreschi.

FRESCOES FROM THE CAMPOSANTO

The frescoes in the Camposanto Monumentale, or rather those which survived the terrible fire of 1944 and are therefore still to be seen today, had once constituted a unique compendium of 14th- and 15th-century mural painting. While Benozzo Gozzoli's marvelous frescoes in the North Gallery, dating to the second half of the 15th century, were characterized by a positivistic and joyous concept of life, those on the

walls of the South Gallery differed greatly in content and inspiration and were conditioned by the Dominican ideas of Eternal Life, considered a liberation from life on earth, achieved through death. They contained an explicit warning to beware of the temptations of daily life, considered as a sort of transition and preparation for true life which is in the other world. These moods are marvelously evoked in the strokes of this intense, vigorous, idylliac yet dramatic painting, which offers us visions of Dantesque inspiration with descriptive elements that hark back to serene and placid themes, in sharp contrast to the narration imbued with

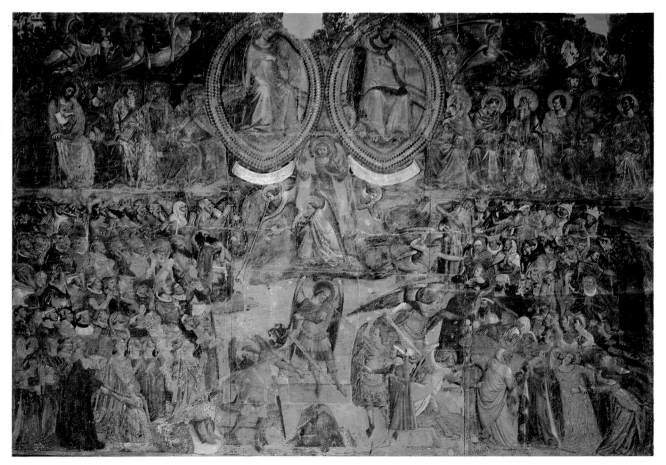

Salone degli Affreschi: The Last Judgement and a detail.

the concept of death, depicted as an ineluctable de-
stroying fury. The key to the interpretation of the
Triumph of Death is to be found in this dramatic
struggle between Good and Evil and in the halucina-
tory conflict between angels and demons for the pos-
session of the souls of the deceased. The fresco is a
masterpiece of its kind in the vigor of interpretation
and the striking realism, crude as it may be, of the pic-
torial narration. Opinions regarding the attribution of
these works are still divided, but the hypothesis pre-
viously proposed indicating Buonamico di Buffalmacco
as the most likely master seems once again to have
found favor.

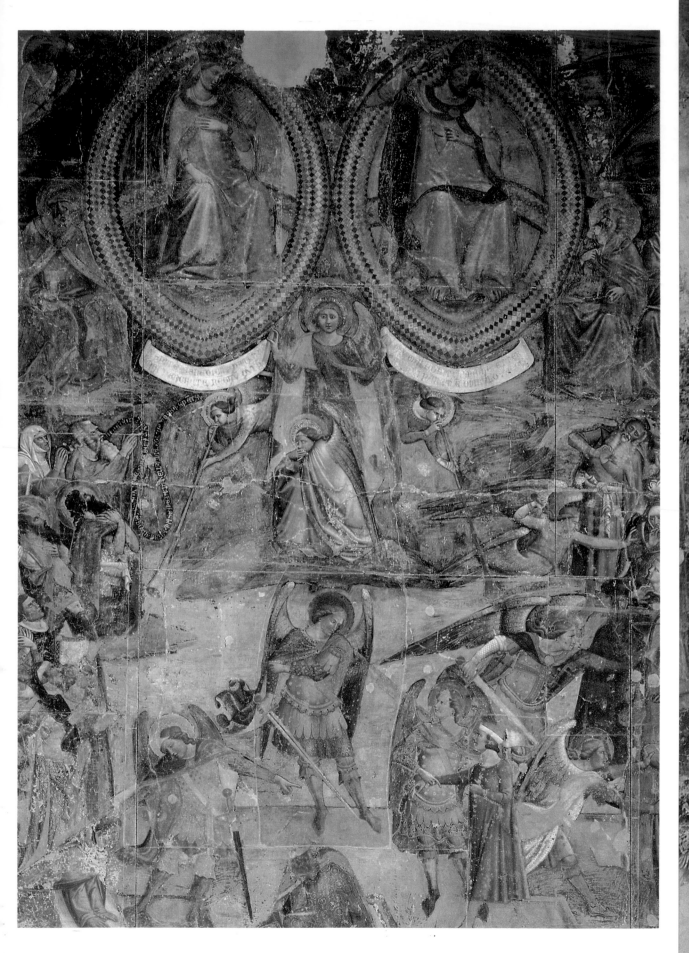

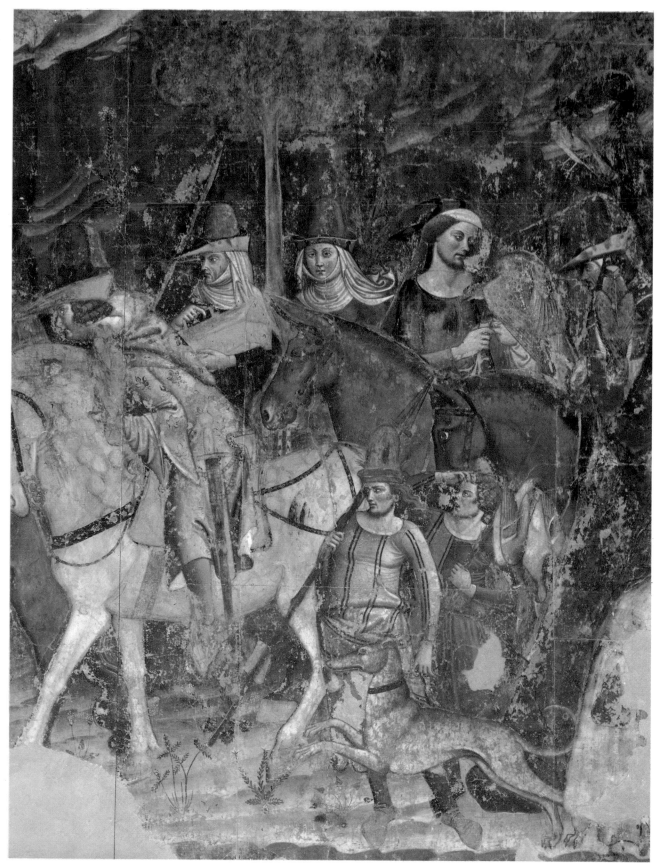

◄ Salone degli Affreschi: a detail of the Last Judgement.

Salone degli Affreschi: a detail of the Triumph of Death, to be seen in its entirety and all of its magnificence in the large foldout.

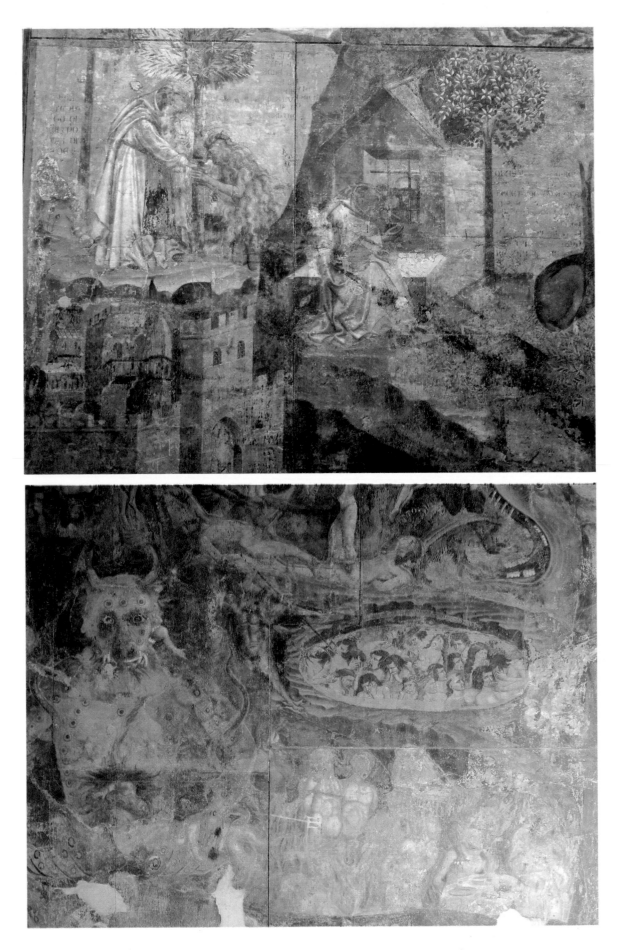

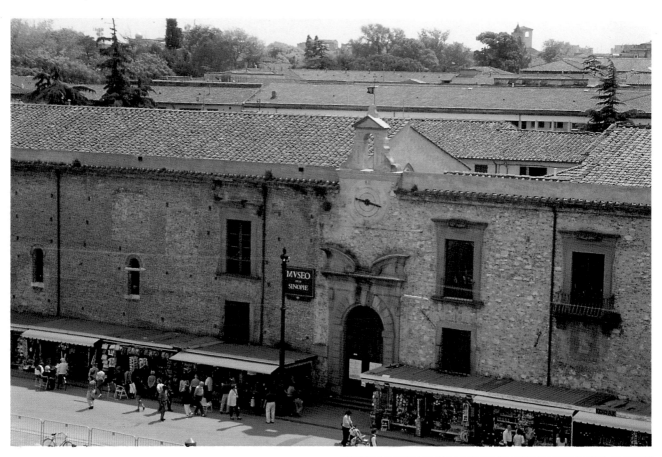

Museo delle Sinopie: exterior

◄ Salone degli Affreschi: a detail of the Stories of the Anchorites.

◄ Salone degli Affreschi: a detail of Hell.

Museo delle Sinopie: detail of the Wedding of Isaac and Rebekah (Benozzo Gozzoli).

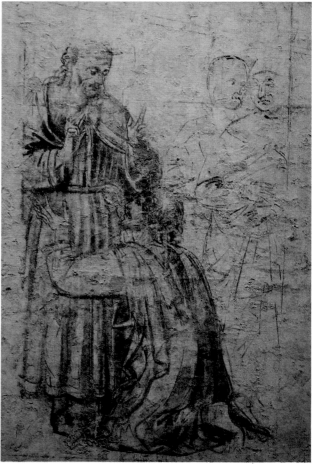

MUSEO DELLE SINOPIE

In 1979 the fascinating collections of this museum were installed in a wing of the Hospital of S. Chiara, which faces onto the *Piazza dei Miracoli.* Construction of the original building, used as a hospice in the Middle Ages, was undertaken in 1257 by Giovanni di Simone. Thanks to a recent timely restoration it has been turned into a museum.

The need to find proper housing for the sinopias first came to the fore when the frescoes of the Camposanto were detached from the walls, revealing the *sinopias* in all their beauty and precise technical significance.

They can be considered as the «matrixes» of the frescoes themselves, drawn on the wall with red ochre

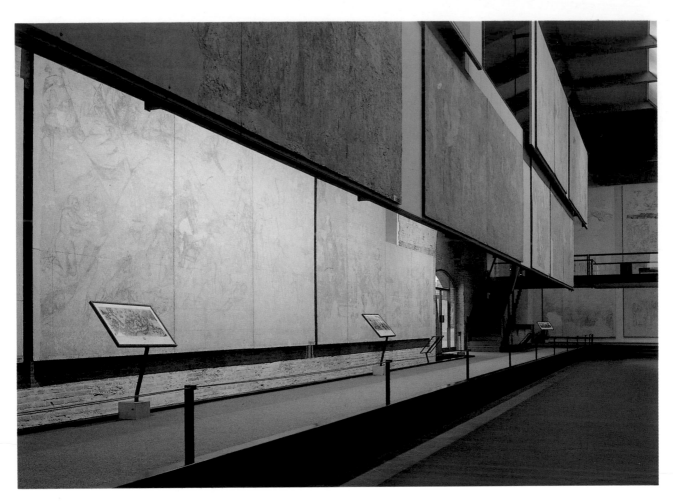

Museo delle Sinopie: view of the room on the ground floor.

Museo delle Sinopie: Stories of Hagar and Abraham ▶
(Benozzo Gozzoli).

Museo delle Sinopie: Stories of Esau and Jacob ▶
(Benozzo Gozzoli).

pigment that came from the Turkish city of Sinope (on the Black Sea), from whence the name. According to another version the term «sinopia» refers to the earth of Siena used by the various masters for their preparatory drawings. These «tracings» or drawings were then covered by the plaster on which the fresco was painted. Attempts made to safeguard these preliminary drawings have resulted in their being put at the disposal of the public where they can be admired in all their integrity. Of the sinopias underlying the most important frescoes, particular mention must be made of the *Triumph of Death*, the *Last Judgement*, *Stories of the Anchorites* (14th cent.), *Crucifixion* (F. Traini); *Ascension* (Buonamico di Buffalmacco); *Theological Cosmograph* (Piero di Puccio); *Scenes from the Old Testament* (Benozzo Gozzoli).

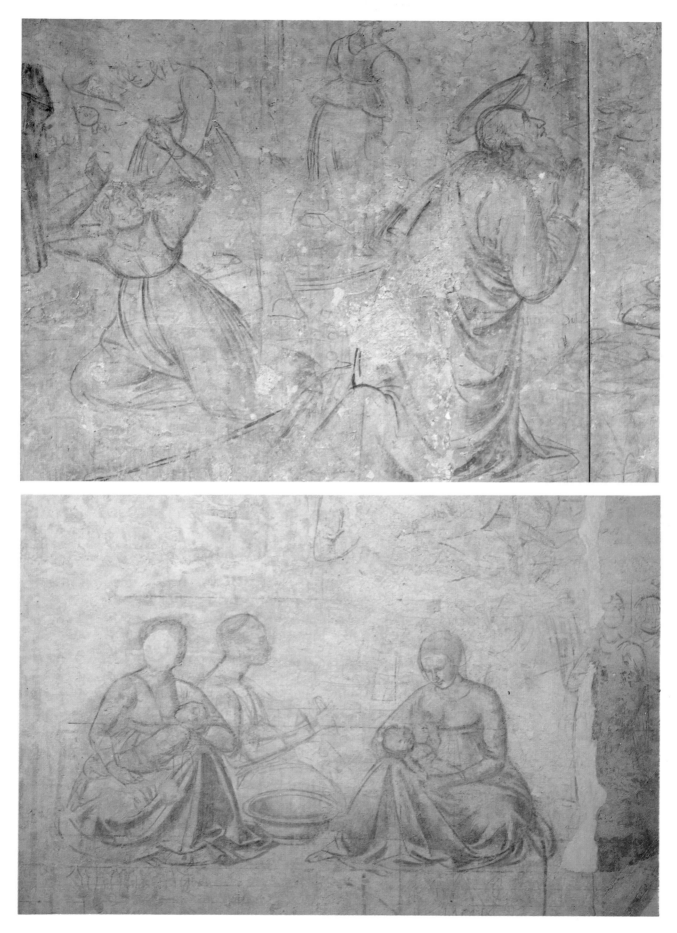

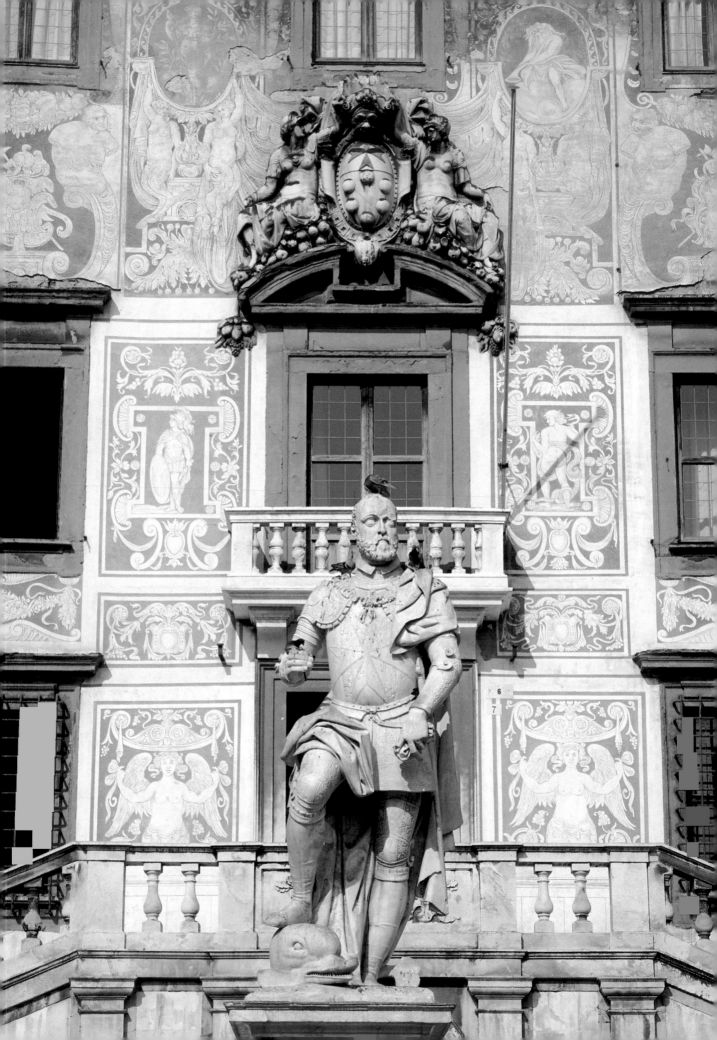

PIAZZA DEI CAVALIERI

In Roman times the Forum stood in this square, most probably also the site of the first settlements. It was known as *piazza delle Sette Vie* at least up to the 16th century when it received its present name. After the *Piazza dei Miracoli,* this is doubtless one of the loveliest and most fascinating places in Pisa, characterized by the Renaissance geometry of the buildings which were in great part redesigned by Giorgio Vasari. The square is an irregular polygon with the late 16th-century statue of *Cosimo I de' Medici* by Pietro Francavilla in its midst. The fountain below, recently restored to its original dignity, is by the same artist and is popularly known as the *Fontana del Gobbo* (Hunchback's Fountain).

PALAZZO DELLA CAROVANA

The most striking piece of architecture, in terms of style and monumentality, is undoubtedly the Palazzo della Carovana, or *dei Cavalieri,* the fruit of Vasari's transformation of the old *Palazzo degli Anziani.* Various elements that were part of the original palace are still visible on the sides, such as the imposing blind arch and a portion of the original **facade** in brick. A double marble staircase, rebuilt in the first half of the 19th century, precedes the charming facade, in part restored. Its three levels are decorated with fine sgraffiti, coats of arms and busts. At the top is a projecting cor-

◄ Detail of the Palazzo della Carovana with the statue of Cosimo I de' Medici (P. Francavilla).

Vasari's Palazzo della Carovana and the Church of Santo Stefano dei Cavalieri.

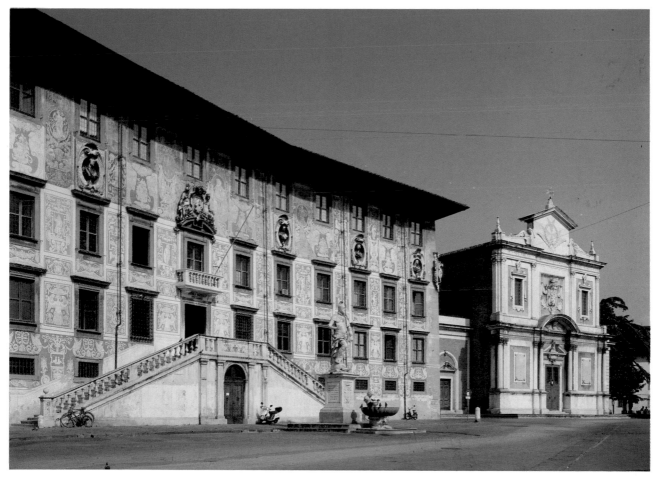

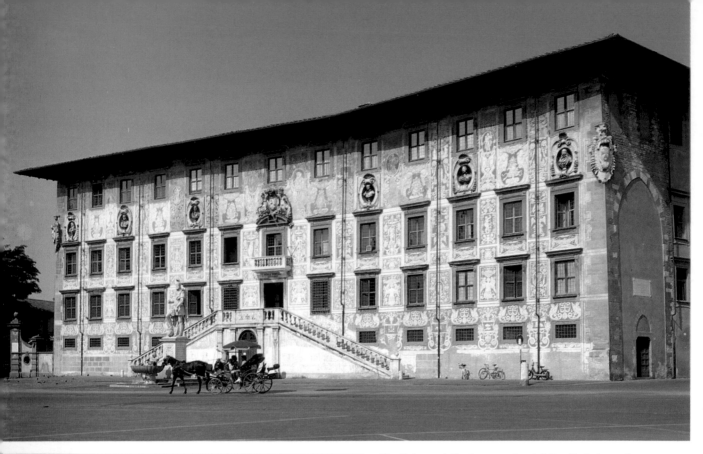

The Palazzo della Carovana (or dei Cavalieri), formerly Palazzo degli Anziani, dominates the piazza where the Roman forum once stood.

A detail of the Palazzo della Carovana with the coat of arms of the Knights of Saint Stephen and the bust of one of the grand dukes of Tuscany.

The statue of Cosimo I de' Medici by Pietro Francavilla. ►

nice molding. The coat of arms of the house of Medici is set over the central balcony at the base of the third tier, while the corners of the building display the coats of arms of the *Order of the Knights of Saint Stephen* (The structure was built for this Order which was founded in 1561 with the open intent of freeing the seas from the threats of Barbaresque piratry). The oval niches on the facade, on the same level as the coats of arms, contain the busts of the Tuscan grand dukes (from Cosimo I to Cosimo III). To be noted in particular the bust of *Cosimo II* (the second from right) by Pietro Tacca. The palace is at present the seat of the prestigious *Scuola Normale Superiore.* Founded by Napoleon in 1810, on the model of the *École Normale Supérieur,* an analogous French university college, it witnessed the studies of illustrious personages such as the eminent man of letters Giosuè Carducci, and Enrico Fermi and Carlo Rubbia, Nobel prizes for Physics, to cite only a few.

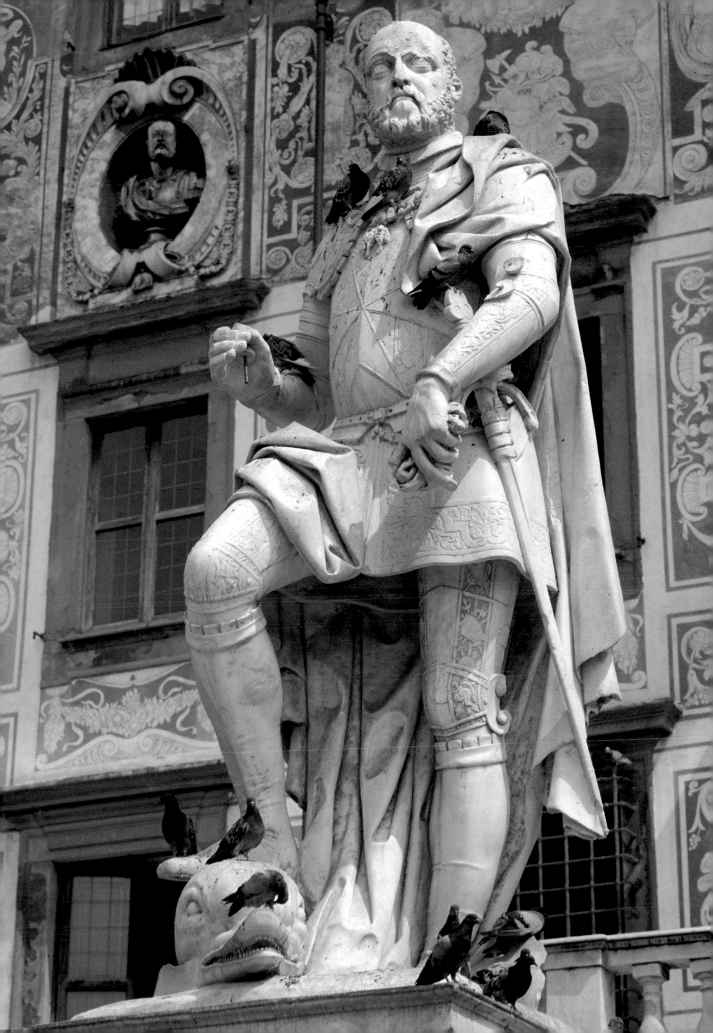

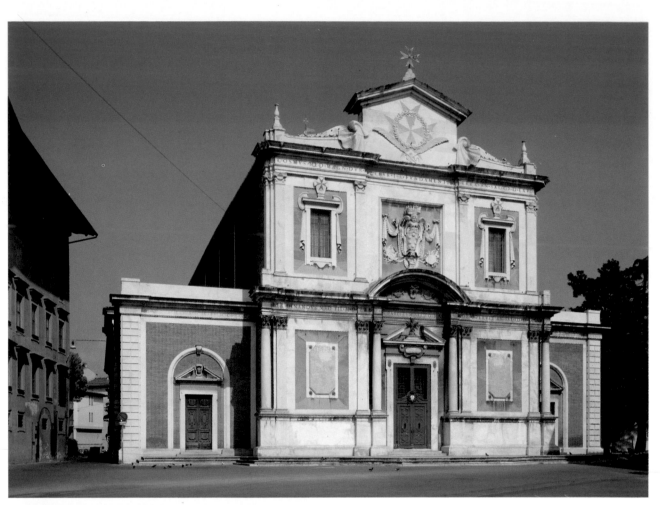

The marble facade of the Church of Santo Stefano dei Cavalieri and a view of the interior of the church.

A detail of the rich coffered ceiling of the Church of ▶ Santo Stefano dei Cavalieri.

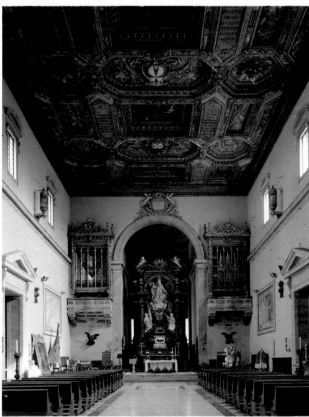

CHURCH OF SANTO STEFANO DEI CAVALIERI

It was built to a design by Vasari in the second half of the 16th century on the site of a pre-existing church. The marble **facade** in two levels, with a great *Cross of the Order* in the summit crowning, is flanked by two wings in brick. On the facade, vertically subdivided by pilaster strips and engaged columns, is the imposing portal crowned by the coat of arms of the Knights of St. Stephen. Work on the facade was begun at the beginning of the 17th century by Giovanni de' Medici. The fine bell tower by Vasari (latter half 16th cent.) in brick and marble rises up at the back of the church.

The **interior** is a hall church and communicates with the side wings. The ornate coffered ceiling contains 17th-century paintings by famous artists (Cigoli, Allori, Ligozzi, Empoli) narrating *stories of the Order of the Knights*. The grandiose high altar is Baroque in style and preserves the relics of Saint Luxurious, contained

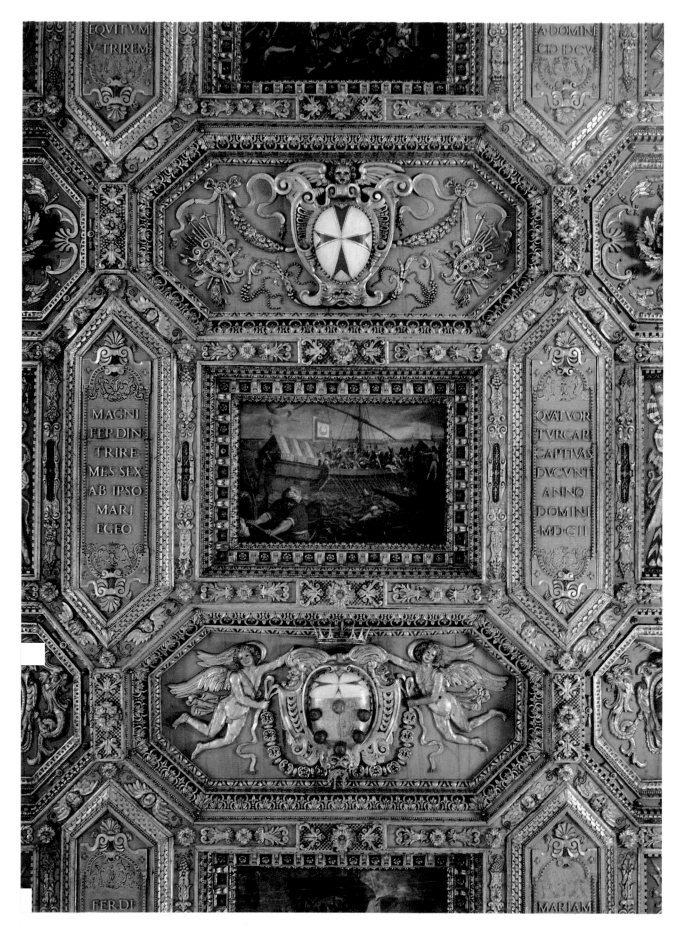

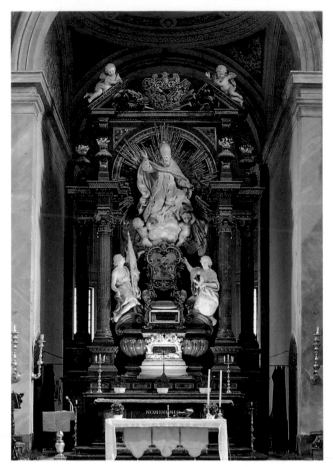

in a crystal urn, with a copy of the bust of the saint on the back, and is dominated by the sculptured effigy of *St. Stephen,* a fine work by G. B. Foggini (18th cent.). Above the pulpit is a canvas by the 17th-century Pisan artist A. Lomi *(The Madonna with Saints Joseph and Stephen).* The first altar of the right aisle has a painting by Vasari, depicting the *Lapidation of St. Stephen.* The tempera paintings illustrating *scenes from the life of St. Stephen* are also by Vasari. *The Birth of Christ,* on the second altar to the left, is by Bronzino (16th cent.). The structure of the church lends itself to its role as a real 'museum' of the Order with the memorabilia from their victories over the Muslim pirates and the conquests of the Order of St. Stephen. Particularly famous is the banner taken from Ali Pascia's Turks during the naval battle of Lepanto (1571).

The sumptuous high altar of the Church of Santo Stefano dei Cavalieri.

The elegant facade of the Palazzo del Consiglio of the Order of the Knights of Saint Stephen.

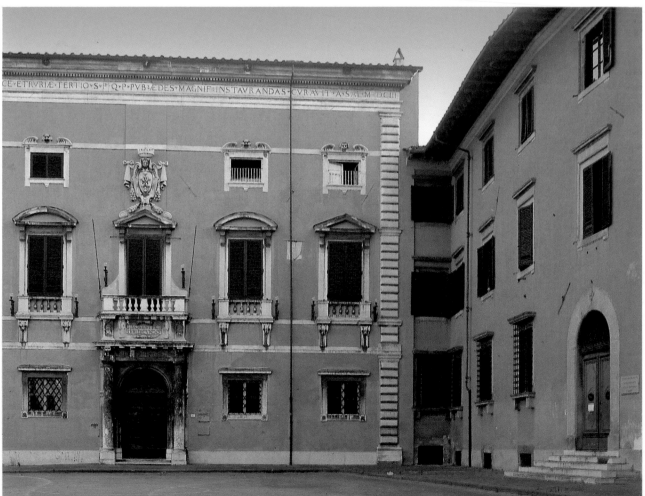

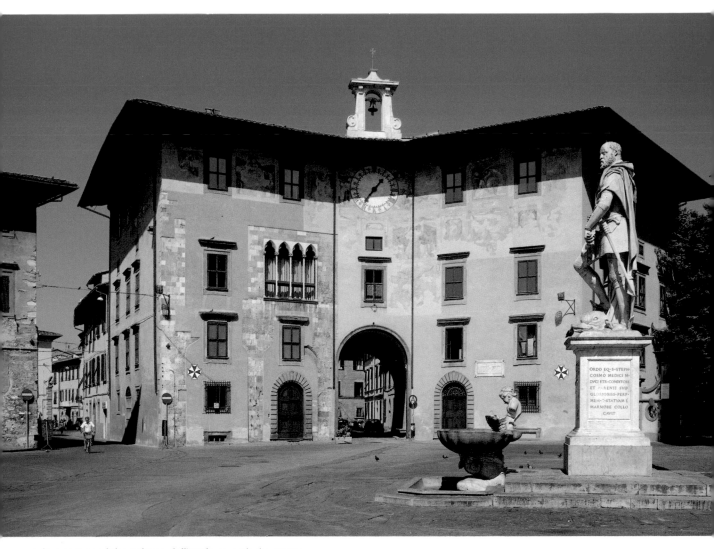

A fine picture of the Palazzo dell'Orologio with the statue of Cosimo I de' Medici and the so-called Fontana del Gobbo.

PALAZZO DELL'OROLOGIO

This historically important palace truly merited its recent restoration. The architectural transformation dating to the early 17th century seems to have been carried out by Vasari who brought together into a single building the tower houses of *Justice* (on the left) and of the *Gualandi* (on the right). The central portion of the palace, with a great arch where recent restoration has brought to light 16th-17th-century frescoes in the vaults, is to all effects the Vasarian 'juncture' created to reunite the two towers. The **facade,** in part frescoed, is distinguished by a four-light mullioned element, with the unplastered ashlars of the original construction clearly evident, by the clock which gives its name to the palace, and by a small open bell gable set above the projecting cornice. The right wing of the pa-lace, formerly *Torre dei Gualandi* or *della Muda*, is famous for the episode of Count Ugolino so marvelously described by Dante (*Inferno* XXXIII, 23-25). At present the palace houses the *Library of the Scuola Normale Superiore* in its renovated rooms. The fine **Palazzo del Consiglio dell'Ordine dei Cavalieri di S. Stefano** is situated in the lower part of the square, on the right looking towards *via S. Frediano*. It too is the result of Vasari's overall restructuration of the square and was materially transformed by Pietro Francavilla at the beginning of the 17th century. The **facade** is particularly pleasing and refined while inside, where standards, banners and uniforms of the Order are kept, traces of medieval building structure are visible. The council hall boasts a fine wooden ceiling with decorations, carving and painting by the Sienese Ventura Salimbeni (*Cardinal Virtues*, 17th cent.). The walls are covered with frescoes of Florentine school (17th cent.).

ABBEY OF SAN ZENO

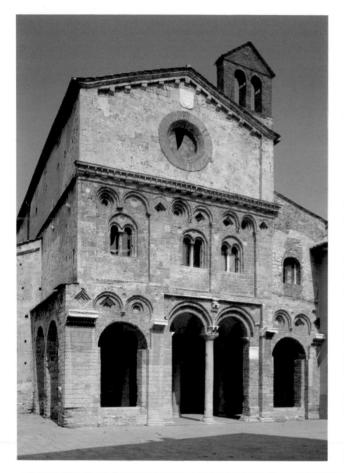

A gem of Romanesque architecture in the city, the abbey stands in an area where archaeologists have uncovered considerable traces of the Roman city, and have broached the hypothesis that there was once an amphitheatre here. The building overlooks a secluded little square not far from the **Porta di S. Zeno,** the old *Porta Monetaria* (13th cent.). The church was deconsecrated and has now been restored to its original splendor by an accurate and competent job of restoration and reclamation, terminated in the early 1970s. The splendid **facade** in several tiers is centered on a charming portico decorated with curvilinear and geometrical motives. On the first floor is a series of lovely arched two-light windows, decorated above by tondos and lozenges set under blind arcading. A string course divides the first floor from the upper part, which has a central oculus and is crowned by an airy small bell gable.

The abbey seems to have existed as far back as the 10th century — and was part of a Benedictine convent, later administered by the Camaldolite order. At the beginning of the last century it was no longer used as a church and the addition of walls and plaster facings hid most of the elegant forms, which have now once more been brought to light. The basilica **interior** has a nave and two aisles, with columns alternating with piers.

The magnificent Romanesque facade of the Abbey of San Zeno and a detail.

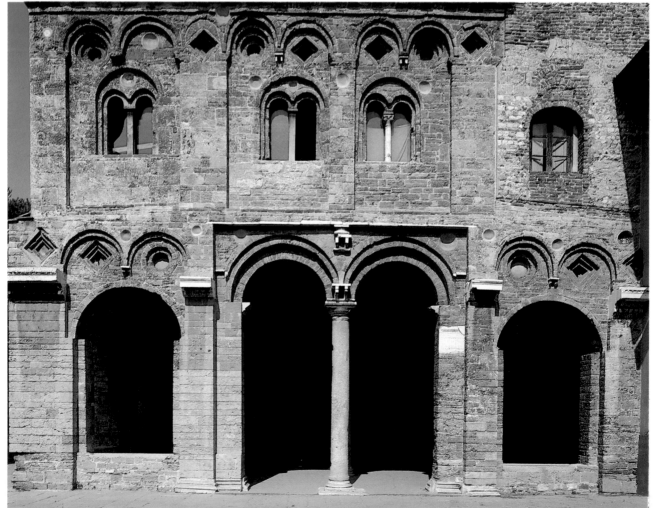

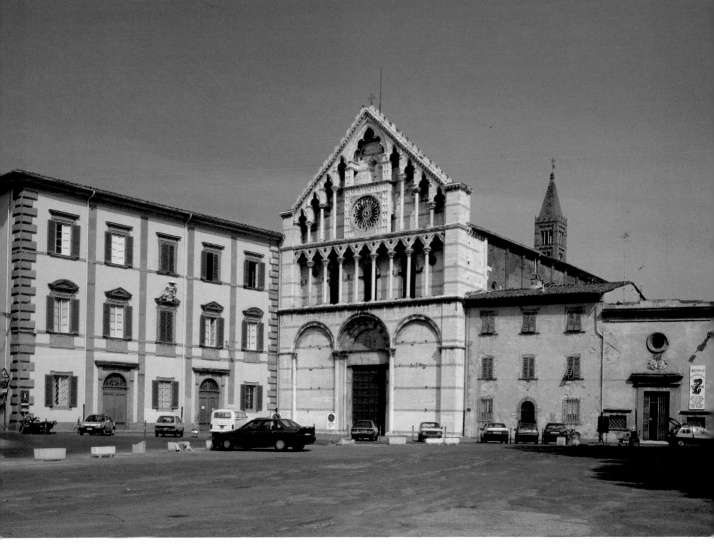

The noble facade of the Church of S. Caterina, overlooking the square of the same name, and a detail of the magnificent pierced rose window and the decorations on the summit.

CHURCH OF SANTA CATERINA

The building overlooks the square of the same name that delimits, on the north, one of the loveliest city squares, the tree-lined *piazza Martiri della Libertà*, which is dominated by the candid marble effigy of *Pietro Leopoldo I*, Grand Duke of Tuscany (L. Pampaloni, 19th cent.).

The church, dedicated to *Saint Catherine of Alexandria of Egypt*, was completed around the middle of the 13th century, on the site of an ancient oratory consecrated to the saint. A Dominican conventual complex in the vicinity was turned into a seminary in the latter half of the 19th century. The splendid marble **facade** is articulated in the upper tiers by two galleries with Gothic arcading. The typical Pisan character is particularly evident in the lower portion of the facade with its three arches. The one which serves as portal is surmounted by a modern mosaic *(Virgin and Child)*. To be noted are the lovely rose window, at the center of the highest part of the facade, and the brick bell tower, set

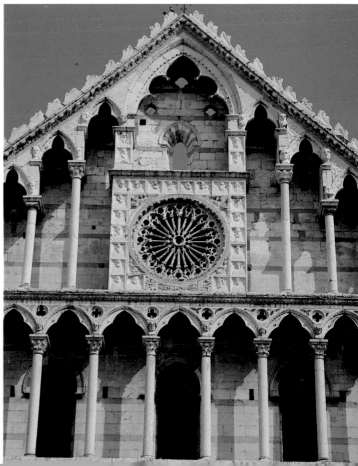

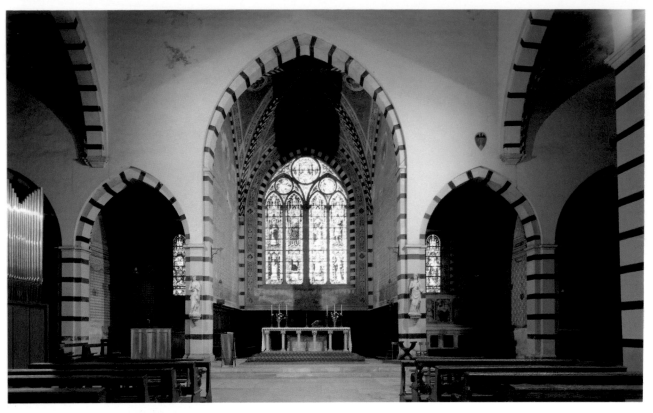

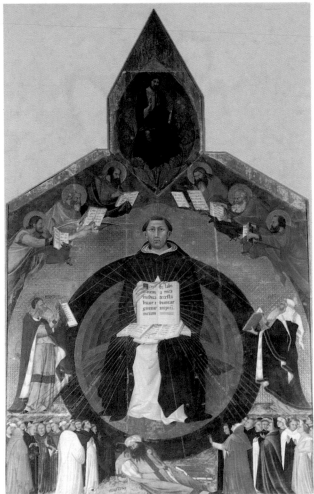

Church of S. Caterina: view of the presbytery with the main apse.

Church of S. Caterina: the Glory of St. Thomas Aquinus (Francesco Traini).

Church of S. Caterina: detail of the sculptures by Nino ▶ Pisano. Angel (left); Virgin of the Annunciation (right).

over the transept, with its pyramidal spire and the fine two- and three-light openings.

The **interior,** with a single spacious nave, was seriously damaged by fire (17th cent.) and subsequently altered by questionable Baroque additions. A timely restoration in the Twenties restored it to its original state while in the early Seventies the pavement was redone. The artistic patrimony of the church, in part transferred to the Museo di S. Matteo, includes a well-known painting by Francesco Traini of *St. Thomas of Aquinas* (14th cent.), the lovely *tomb of Simone Saltarelli*, a refined work by Nino Pisano (14th cent.), a canvas by Raffaele Vanni depicting the *Stigmata of St. Catherine of Siena* (17th cent.), a *Virgin and Child with Saints Peter and Paul* by Bartolomeo della Porta (16th cent.), two sculptures by Nino Pisano (*Annunciation figures*, 14th cent.), a 15th-century triptych of Donatello's circle, a *Pietà* by Santi di Tito and a painting by Lomi depicting *St. Catherine of Alexandria.*

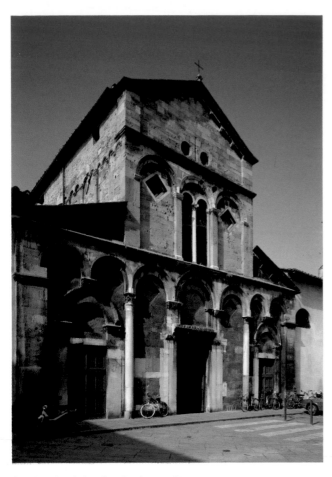

The facade of the church of S. Frediano.

A view of the medieval Torre del Campano.

CHURCH OF SAN FREDIANO

This church can be reached by walking through one of the most fascinating parts of the old city. One encounters first *piazza delle Vettovaglie*, an interesting open space with a fountain, surrounded by a fine 16th-century portico. The fruit and vegetable market is held here and characteristic food shops are to be found under the loggias. The surrounding streets, animated by the picturesque market where farm produce is sold at typical stands where venders still cry out the praises of their wares, are characterized by old buildings in unplastered masonry of medieval type. Particularly striking is the so-called **Torre del Campano,** an imposing 13th-century structure in Verrucana stone, marked by a great walled-up Gothic arch. Of old known as the *Torre dei Caciaioli* (Cheese-mongers' tower) it became famous in the second half of the 18th century when its bell sounded the beginning of lessons in the nearby University.

The Church of San Frediano, its origins dating all the way back to the 9th century, is a typical example of Pisan Romanesque church architecture. Its present aspect probably dates to the 11th century and the foundation promoted by the Buzzaccherini-Sismondi. The **facade** overlooks a small intimate square defined by a fine medieval building with occasional traces of a marble multiple mullioned window. The lower portion is characterized by blind arcading, decorated with lozenges and in part supported by engaged half columns. An elongated two-light window opens at the center of the upper tier, and the external arcading is also decorated with lozenges. The crowning section, distinguished by two small oculi (or round windows), indicates that the entire building was heightened after a fire (latter half 17th cent.).

The **interior,** with a nave and two aisles, has a rich 17th-century high altar in marble. The *Cappella Gherardesca* contains a painted *Crucifix* (13th cent.) and an *Adoration of the Magi* by the 16th-17th century Pisan painter A. Lomi. Other outstanding works include paintings by the Sienese artist Ventura Salimbeni *(Annunciation, Birth of Christ, Exaltation of the Cross, Invention of the Cross)*, a painting by Tempesti *(Sacred Heart)* and *Events from the Life of Saint Brigid* by A. Tiarini (17th cent.). Also noteworthy is the robust campanile in brick.

Archaeological trial digs in the adjacent Piazza Dante have revealed evidence of Etruscan (7th cent. B.C.), Roman (Augustan age) and medieval settlements. A mass burial site was also found. It contained skeletons of children and adults who died during an epidemic of the plague in the 14th century, probably the one cited by Boccaccio in his Decameron.

PALAZZO DELL'UNIVERSITÀ

The Pisan 'Studio', documented as early as the 12th century, developed in the first half of the 14th century, thanks to Fazio della Gherardesca, and was officially 'consecrated' by a decree of Pope Clement VI (1343), which effectively institutionalized the University of Pisa. Lorenzo the Magnificent promoted this cultural institution and the number of students increased, including those who came from abroad. After the reforms instituted by Cosimo I de' Medici (first half of the 16th cent.), the development of the university continued in the Granducal period, when the surgeons' school with its own 'anatomical theatre' was particularly well known. Currently the University of Pisa is one of the most prestigious and qualified on a worldwide level.

The construction of the Palazzo dell'Università was begun in 1489 by Lorenzo the Magnificent on a site in precedence used by the Romans (most probably for a temple consecrated to Vesta) and which was then a market place *(Piazza del Grano).* The building, known also as *Palazzo della Sapienza* — apparently due to a quotation from the Bible that is still visible on a plaque at the entrance — has an imitation Renaissance **facade,** finished in 1911. A loggia runs across the upper part of the spacious porticoed courtyard which is pure Renaissance in style. To be noted, at the back of the courtyard, the group of figures in bronze *(War Memorial)* by Gigi Supino (1924). Among the numerous inscriptions and busts, dedicated to illustrious academicians and scholars, of particular note is the *bust of Antonio Pacinotti* (1934). Access to the *Aula Magna Storica,* decorated with paintings, portraits and the *statue of Galileo* by P. Emilio Demi (1839) is from here. On the first floor is the *Nuova Aula Magna,* frescoed by the contemporary artist De Carolis and showing *Clement VI, Cosimo I and Galileo.* It was here that Pope John Paul II delivered a homily during his pastoral visit to Pisa (September 1989).

Palazzo dell'Università: the famous courtyard of the Sapienza.

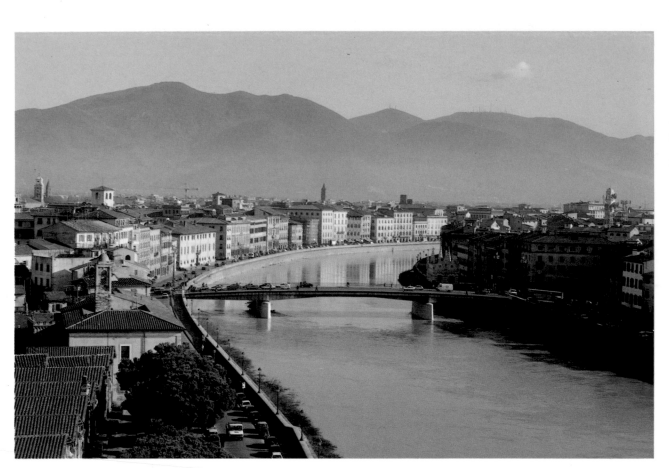

Panorama along the lungarni.

LUNGARNO PACINOTTI

For those who arrive from *piazza Garibaldi*, this part of the lungarni furnishes the occasion for a pleasant walk, while admiring the curve of the river as it loops around, and taking note of the facades of various important buildings. A bit further on, an *inscription* on the parapet of the river recalls the landing of Garibaldi who had been wounded on the Aspromonte (1862).

Palazzo Agostini, conspicuous for the reddish color, is a 15th-century building notable for its fine brick facade, for its terracotta decoration and the double tiers of two-light windows. Most likely the building is the result of the union of two ancient tower houses. The historical *Caffè dell'Ussero,* which traditionally dates to the end of the 18th century, is situated on the ground floor. During the Risorgimento it was the fervid hotbed for liberal agitation and numbered among its clients figures who were to become famous (Francesco Domenico Guerrazzi, Giuseppe Giusti, Giosuè Carducci, Renato Fucini).

The **Church of the Madonna dei Galletti** is small but charming, a magnificent example of Baroque reconstruction (17th-18th cent.). The origins of the building, once known as *S. Salvatore in Porta Aurea,* date to the 13th century. Among the most important works mention may be made of the fresco on the high altar *(Madonna and Child),* thought to be by Taddeo di Bartolo, two candelabrum *angels* in wood (18th cent.) and the fine richly decorated coffered ceiling.

Palazzo Upezzinghi, know also as *Lanfreducci,* is a fine late 16th-century construction, important for its harmonious marble facade. The three levels of the facade are scanned by pronounced string courses, while the windows are decorated alternatively by triangular and curvilinear pediments. Note the curious motto, *Alla Giornata* (Day to day), over the majestic portal surmounted by an elegant balcony. The exact meaning remains a mystery even though a plausible explanation might be that in the construction of the building count was kept of the days of work. At the back of the structure, which includes a fine tower in brick, unquestionably medieval elements of architecture are to be found. The glorious standard of the Tuscan university volunteers at Curtatone and Montanara (1848) is kept here in the seat of the university *rectorship.*

Beyond *piazza F. Carrara* with its *Monument to Ferdinand I de' Medici,* a late 16th-century work by P. Fran-

Lungarno Pacinotti.

Palazzo Reale and the Torre della Verga d'Oro (Tower of the Golden Rod) on Lungarno Pacinotti.

cavilla, a follower of Giambologna, and manifestly celebrative in intent, stands the fine **Palazzo Reale** (formerly *Granducale*). It was built in the Medicean period (latter half of 16th cent.) on a project by Buontalenti, and is a typical example of the imposing might of the 16th-century mansions. Formerly the residence of the Medici family and then of Lorraine, it subsequently housed the kings of Italy. The building, dominated by the *Torre della Verga d'Oro* — a typical example of medieval architecture — is currently the seat of the *Sovrintendenza per i Beni Ambientali, Architettonici, Artistici e Storici* (Bureau of Environmental, Architectural, Artistic and Historical Assets). Four rooms (open upon appointment) have been organized and constitute the initial nucleus of the branch section of the Museo Nazionale di San Matteo. It contains the collections donated by the doctor and collector, Antonio Ceci (1852-1920). Included are paintings by Italian and Flemish 15th-17th century artists; pencil portraits (19th cent.); portraits by Italian, Flemish, French and English painters from the 16th to the 19th centuries; ivory miniatures (18th-19th cent.); small bronzes; a medal collection and Italian and Oriental ceramics.

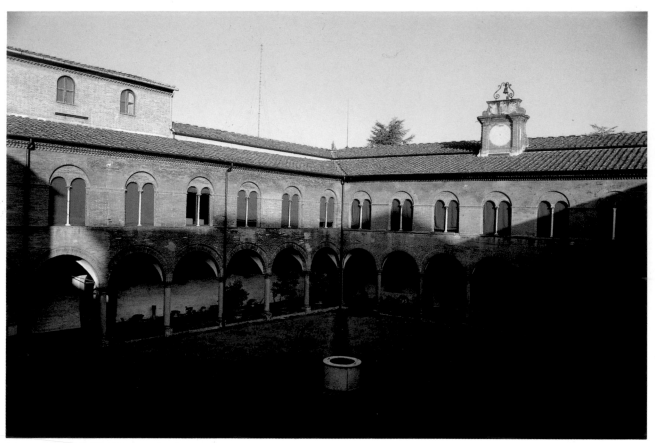

Museo Nazionale di S. Matteo: the courtyard.

MUSEO NAZIONALE DI SAN MATTEO

The beginnings of the Museum date to the 18th century although it was not until after World War II that it was definitively installed in its present premises. Restructuration is in the offing, with the addition of space currently occupied by the University, and a branch section in the former **Palazzo Reale** (16th cent.) is also planned. The collections are located in a building with a porticoed courtyard, with elegant two-light windows on high. Originally a Benedictine convent (11th cent.), it was subject to various transformations and enlargements up until the 19th century. An important place in the collections is reserved to medieval pottery, represented by numerous *bowls* from throughout the Mediterranean area, and in particular from Islamic countries. To be noted are the bowls from Egypt (11th cent.) and the ornamental majolica used to decorate churches (13th cent.) as well as numerous chance finds brought to light in excavation works in various parts of the city. Pisan 12th- and 13th-century painting is represented by remarkably fine pieces such as the so-called *Calci Bible* (12th cent.), a superb example of an illuminated codex, the painted *Crucifixes* formerly in the churches of S. Paolo all'Orto, S. Sepolcro and the Convent of S. Matteo, as well as fragments of detached frescoes from the churches of S. Pietro in Vinculis and S. Michele degli Scalzi. Some of the most important painters in 13th-century Pisa were Giunta di Capitino *(Cross of S. Matteo)* and Berlinghiero *(Crucifix of Fucecchio)* who headed a school that made a name for itself in the area of Lucca as well as in Emilia and Umbria. Byzantine influences are to be found in the works of Enrico di Tedice and the Master of S. Martino, who painted a wonderful panel with *Scenes from the Life of Saint Anne.* The marvelous *Polyptych* which Simone Martini painted for the Church of S. Caterina occupies a place all its own in the series of 14th-century paintings, while other outstanding names include the Luccan Deodato Orlandi, Giovanni di Nicola, Francesco Traini, Lippo Memmi, Turino Vanni, Jacopo di Michele, Neruccio Federighi, Cecco di Pietro and Francesco Neri da Volterra. Also to be noted are the *Madonnas* by Barnaba da Modena, the *Polyptych* which Spinello Aretino made for the Cathedral, the works by Martino di Bartolomeo and Taddeo di Bartolo and the *Crucifixion* by Luca di Tommè. The finest sculpture of the time was the work of Nicola and Giovanni Pisano, Tino di Camaino and Andrea and Nino Pisano, whose exceptionally fine *Madonna del Latte* was formerly in Santa Maria della Spina. Polychrome and gilded wood sculpture is represented by several well-known artists: An-

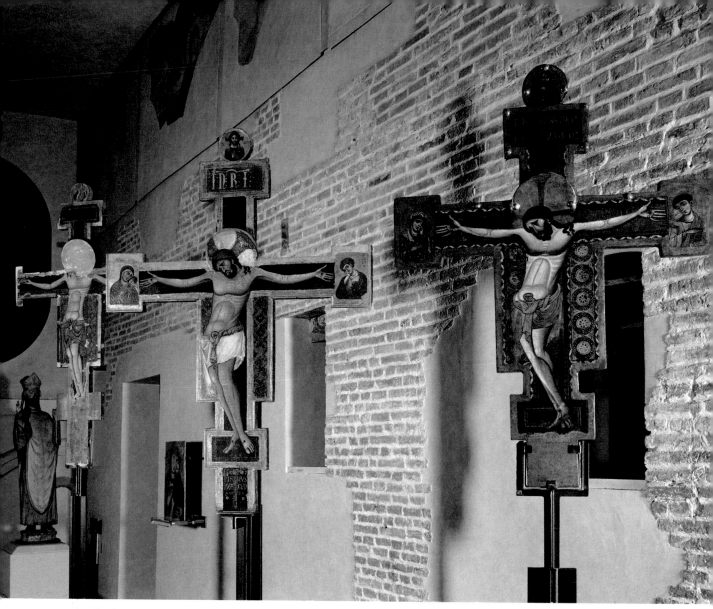

Museo Nazionale di S. Matteo: 13th-century painted
Crosses of Pisan school.

drea Pisano *(Angel)*, Agostino di Giovanni *(Virgin of the Annunciation)* and Francesco di Valdambrino *(angels, Madonnas of the Annunciation)*. The figurative arts of the 15th century were influenced by the works of Florentine artists or of those who studied there. An example is Masaccio and his fine *St. Paul* on a gold ground, or Fra Angelico *(Madonna and Child)*, or Gentile da Fabriano *(Madonna of Humility)* or Domenico Ghirlandaio *(Madonna and Child with Saints)*, while Benozzo Gozzoli was principally engaged in creating the frescoes in the Camposanto. Of particular note among the 15th-century sculpture is the splendid *Bust of St. Luxorious*, in cast bronze, chased and gilded, a marvelous piece by Donatello, originally in S. Stefano dei Cavalieri, while other works include glazed Della Robbia terracottas, works by Michelozzo

and artists trained in the school of Jacopo Rustici. Outside the museum, on the small square of the same name, is the old **Church of San Matteo.** One side overlooks the lungarni, where the robust square campanile also stands. The elements that are part of the original Romanesque structure (11th cent.) are visible in the bell tower and the blind arcading on the side, while the 17th-century facade, in marble, is similar to that of many other Pisan churches, revealing the Medici restructuration after a fire in the early 17th century.

The single-aisle interior is Baroque in style and contains various paintings, including a *Celestial Glory of St. Matthew* (18th cent.) by Francesco and Giuseppe Melani, a *Vocation of St. Matthew* (17th cent.) by Francesco Romanelli and the *Martyrdom of St. Matthew* (17th cent.) by Sebastiano Conca.

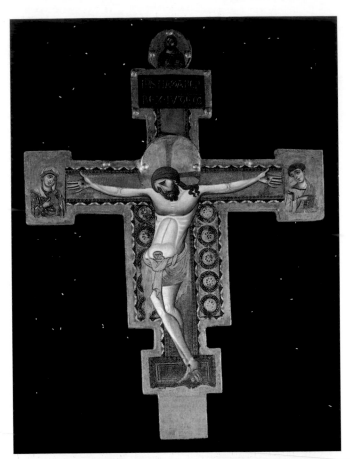

Museo Nazionale di S. Matteo: 13th-century processional Cross (Giunta Pisano).

The polyptych with the Madonna and Saints (Simone Martini) in the Museo Nazionale di S. Matteo, and a detail.

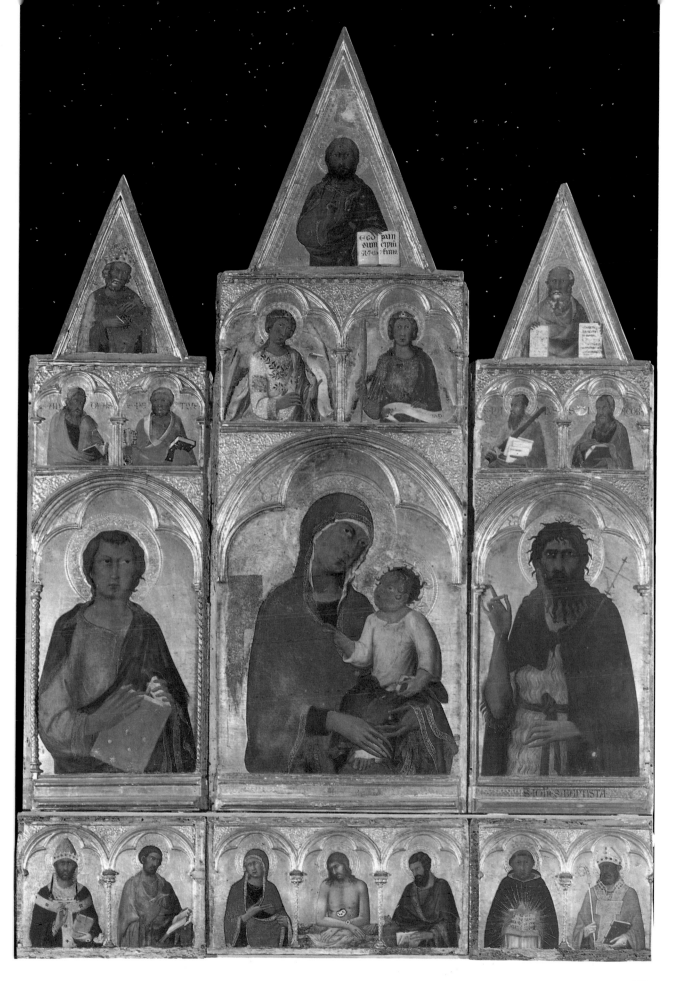

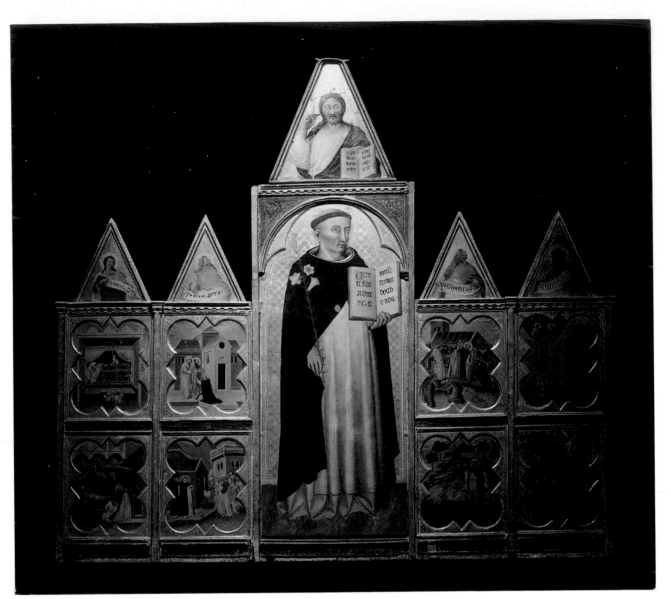

Museo Nazionale di S. Matteo: polyptych of St. Dominic
with scenes of his miracles (Francesco Traini).

Museo Nazionale di S. Matteo: Virgin of the ▶
Annunciation (Agostino di Giovanni).

Museo Nazionale di S. Matteo: processional banner by a ▶
14th-century Pisan artist.

Museo Nazionale di S. Matteo: Madonna and Child with ▶
Saints (Giovanni di Nicola).

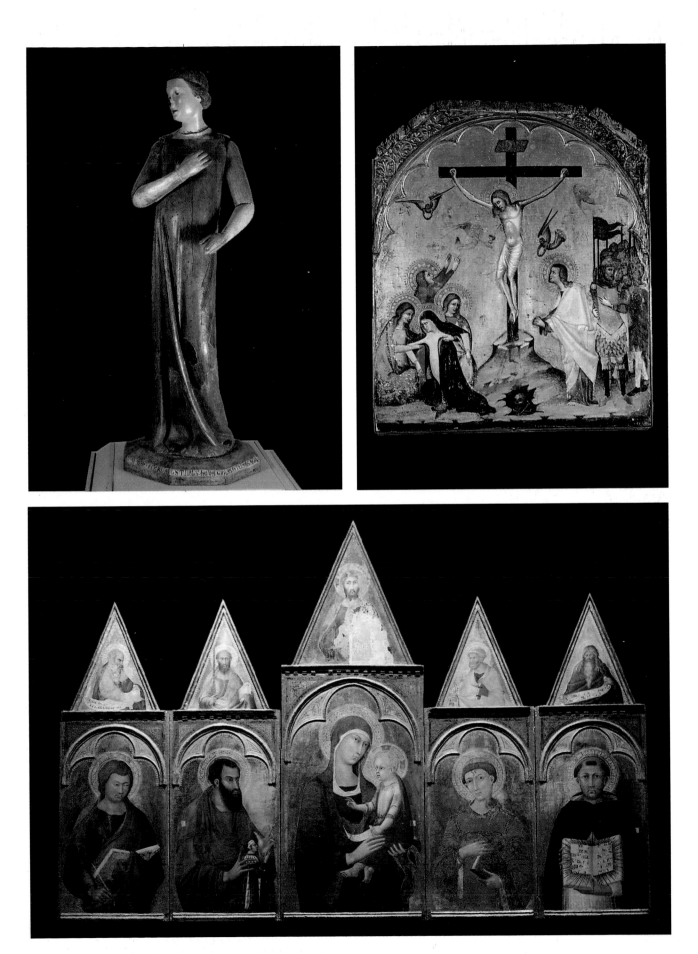

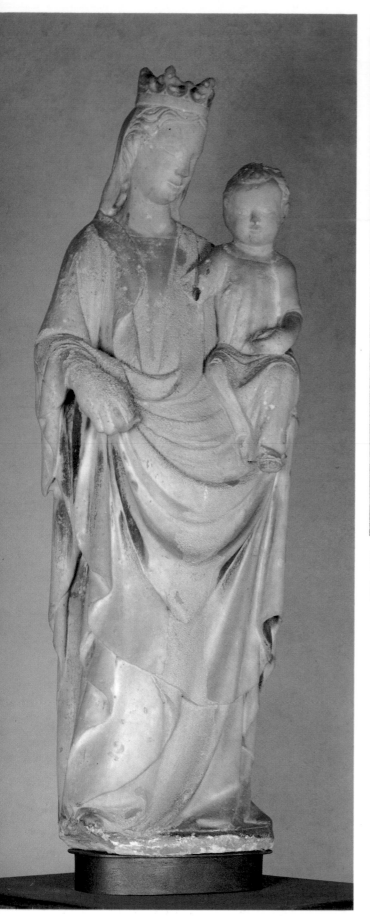

Museo Nazionale di S. Matteo: St. Paul on a gold ground (Masaccio).

Museo Nazionale di S. Matteo: Madonna and Child (Nino Pisano).

Museo Nazionale di S. Matteo: Madonna and Child, ▶
Stories, St. Martin and the Beggar
(Maestro di San Martino).

Museo Nazionale di S. Matteo: Madonna of Humility
(Gentile da Fabriano).

Museo Nazionale di S. Matteo: St. Sebastian and St. Roch
(Florentine 15th-century painter).

Museo Nazionale di S. Matteo: Madonna del Latte (Andrea
and Nino Pisano).

Museo Nazionale di S. Matteo: Bust of St. Luxorious ►
(Donatello).

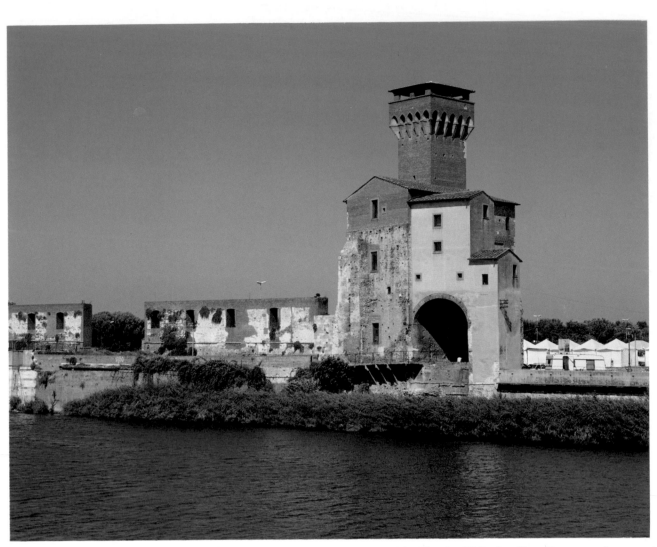

The complex of the Citadel, dominated by the Guelph Tower, which characterizes the westernmost part of the lungarni of Tramontana.

The Church of S. Paolo a Ripa d'Arno, once known as ▶ Duomo Vecchio, is one of the outstanding examples of Pisan Romanesque.

MEDICI ARSENAL AND FORT

The Medici Arsenal stands on the site once occupied by the *Orto Navale*, which was the first nucleus of the Botanic Gardens. Works for the construction were begun around the middle of the 16th century by the house of Medici, with the intent of reviving the Pisan naval traditions of old. The building sheds, with mighty archways, still bear the Medici coat of arms: various inscriptions celebrate the naval victories of the fleet of the Order of the Knights of Stephen, who used these hangars to shelter and repair their ships. In the 18th century the Arsenal was converted into stables for the horses of the reigning house and then of the army: this is why it is also popularly called *Stalloni* or *Stallette*.

The Cittadella, also called *Fortezza Vecchia*, stands not far off on the site known as *Terzanaia*. On the whole, the building as it is today is the result of a postwar reconstruction, terminated in the second half of the 1950s. To be noted the characteristic silhouette of the *Guelph Tower* which distinguishes this portion of the lungarni. The apex, crenellated and roofed over, is supported by a row of projecting corbels (a cantilevered structure that juts out to repel the attackers), above which are charming unsupported arches. The origins of this fortified complex date to the medieval period — the vestiges of the old Republican arsenal (13th cent.) were here — even if subsequent transformations, reconstruction and its use for other purposes have considerably altered the original features.

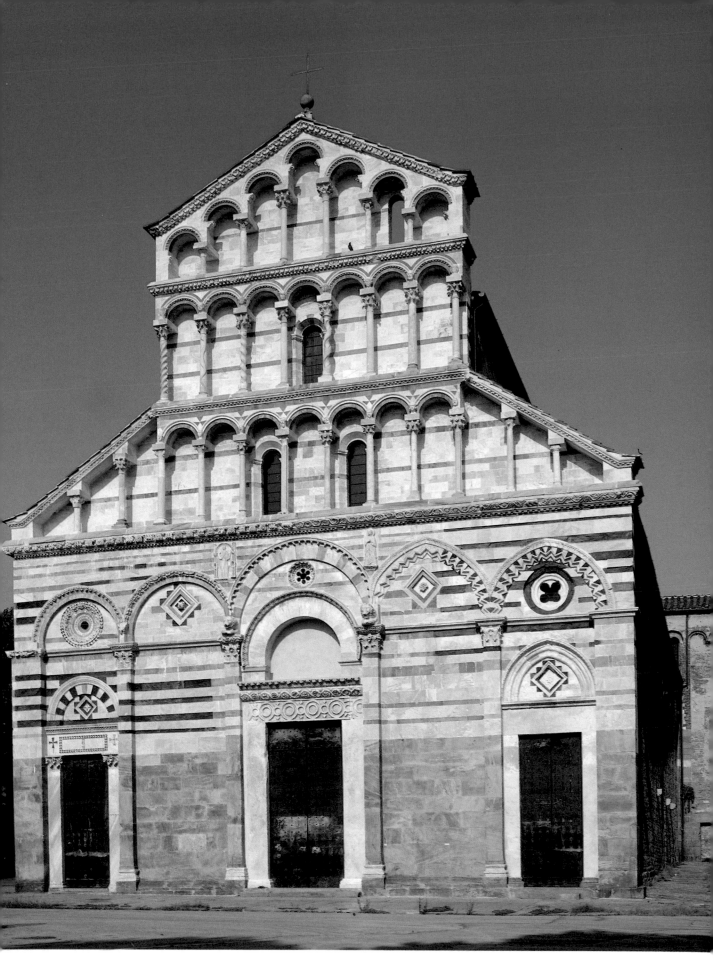

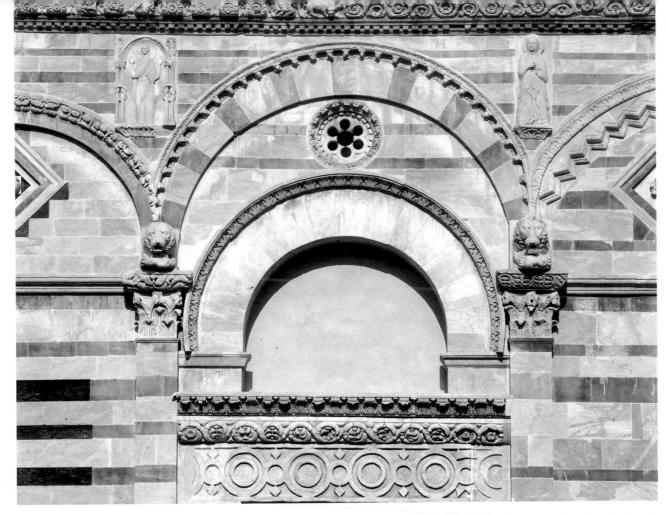

S. Paolo a Ripa d'Arno: two details of the facade.

CHURCH OF SAN PAOLO A RIPA D'ARNO

The green and tree-shaded *piazza San Paolo a Ripa d'Arno* opens up beyond the 13th-century **Porta a Mare**, near which is an 18th-century tabernacle with the effigy of the *Madonna dei Navicellai*. Overlooking the piazza is the church of *San Paolo a Ripa d'Arno*, rightly considered one of the loveliest in Pisa, and which lends its elegant charm to this portion of the splendid lungarni of *Mezzogiorno*. Founded in the 9th century, it was thoroughly transformed between the 11th and 12th centuries. Since it served as cathedral until the construction work for the cathedral of *Santa Maria Assunta* was terminated, it is often also called *Duomo Vecchio*. Part of a Vallombrosan abbey from the 11th to the 16th century, it was then given in commendam to the Grifoni family, which therefore acquired the use of the ecclesiastic benefits.

The building, with splendid basilican proportions, is crowned by a hemispherical dome set at the intersection of the nave and the transept. The **facade**, now restored to its original splendor by competent restoration, uses the architectural and ornamental formulas to be found in the Cathedral. The lower level, with three portals, is vertically scanned by pilasters from which spring blind arches, decorated with lozenges and tondos. To be noted the decoration above the main portal which recalls Byzantine motives. Above are three tiers of small loggias, supported by slender columns (some of those in the second tier are twisted). The lovely left side has a base in stone ashlars, on which the horizontal bichromatic marble bands are set, while the blind arcading, decorated with lozenges and marble intarsia, fuses architecturally with the upper level, where a long row of arches is supported by elegant columns. To be noted also the left transept, with a Roman sarcophagus on the portal, over which are polychrome marble ornaments in Egyptian style, and the handsome semi-circular apse.

The beauty of the imposing and monumental **interior** lies in the sober elegance of its bare walls. Two rows of powerful columns in Elba granite, with elegant Romanesque capitals, divide the space into a nave and two aisles. Near the intersection of the transept, two piers support an imposing triumphal arch. After the entrance on the right is a large strigilated Roman sarcophagus (decorated with undulated fluting, 4th cent.) with a central mandorla (oval frame) with the portraits of the *Husband and Wife*. It was formerly used as a tomb for Burgundio, a famous 12th-century Pisan jurist and man of letters (commemorative *plaque* above the sarcophagus). The few works of art now to be seen

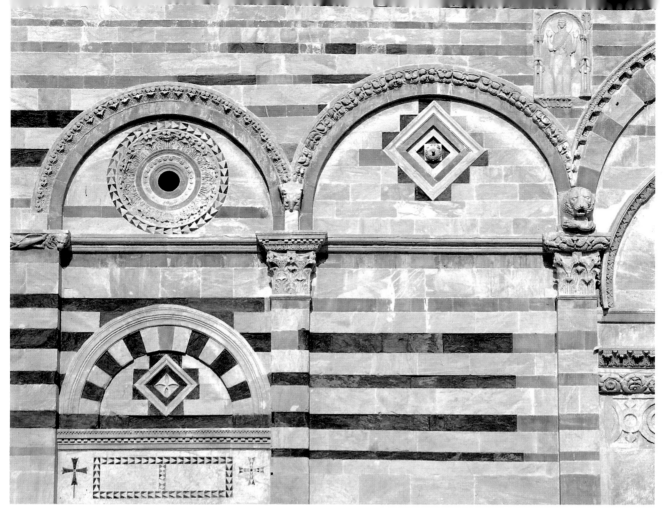

The unusual octagonal Chapel of St. Agata.

(such as the panels of the *Stations of the Cross* and the Baptismal Font in the left transept) are of modern make, with the exception of the 14th-century *Crucifix* in the apse and the painting by Turino Vanni of the *Virgin and Child with Saints Ranieri, Torpè, Bona and Gherardesca* (1397). Vasari says that beautiful fresco cycles by famous artists such as Simone Martini and Cimabue once covered the walls. Today only fragments are left, such as those on the last pier on the left, which depict *John the Evangelist* and *St. Francis.* To be noted also (second capital on the left) the figures of *St. Paul* and *St. Peter.* The presbytery is lighted by a tall 14th-century Gothic two-light window, with stained glass of the period depicting the *Redeemer and Apostles.*

Behind the church, in a field and striking in its isolation, stands the very old **Chapel of Saint Agata.** It dates to the 12th century and its unusual architectural features (octagonal floor plan crowned by an octagonal pyramid) closely recall the temple of the Holy Sepulcher: it therefore seems likely that it was also designed by Diotisalvi. To be noted the elegant three-light windows, set into four walls, and the charming crowning of unsupported small arches which marks the base of the pyramid.

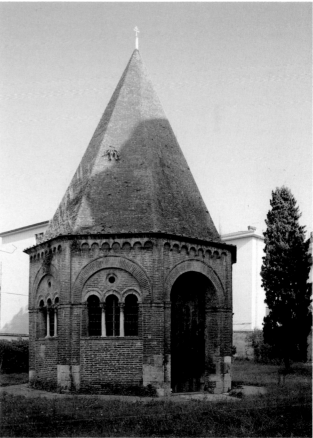

CHURCH OF SANTA MARIA DELLA SPINA

Gem of late Gothic architecture, this church is a marvelous ensemble of lacy openwork in marble with pinnacles, aediculas, tabernacles and spires, which make this stretch of the lungarno an unforgettable setting. The church owes its curious name to the fact that in the first half of the 14th century, it contained the historical relic of a thorn from the crown of Christ, a gift of Betto di Mone Longhi, now preserved in the *Church of Santa Chiara,* near the Hospital of the same name.
First built as the *Oratory of Santa Maria del Pontenovo* (1230), it was attributed to Giovanni Pisano, who apparently only worked on some of the sculptures. Enlarged thanks to the Gualandi (14th cent.) it was frequently subject to flooding and infiltrations of water, since it stood right on the river bed of the Arno. In 1871 it was taken apart piece by piece and then reassembled on its present site. The lovely **facade,** articulated by the geometric ornamentation of the arch and triangle, is extremely ornate, with handsome rose windows in the triangular side gables, while the aediculas and tabernacles house statues by Giovanni di Balduccio and Nino Pisano. The right side, with an extraordinary wealth of sculptural decoration, has panels on either side of the portal in the manner of Andrea Pisano, while the aediculas and the upper spires contain sculpture by artists of the circle of Giovanni and Nino Pisano. The pinnacle at the top is crowned by a copy of Andrea Pisano's *Madonna and Child.*
In the **interior,** of hall type, the presbytery is separated from the rest by three arches. The elegant windows let in light and accentuate the two-colored marble. Particular mention should be made of the 16th-century tabernacle by Stagi, which contained the relic of the thorn, and the marble sculpture by the Pisanos (Andrea and Nino) of the *Madonna of the Rose with the Child and Saints Peter and John.* In the vicinity of the church is the **Ponte Solferino,** reconstructed in 1974, to replace its predecessor which fell after the terrible flood of the Arno (4-11-1966) in which the *lungarno Pacinotti* also in part collapsed.

The elegant profile of the Church of S. Maria della Spina highlights the lungarni of Mezzogiorno.

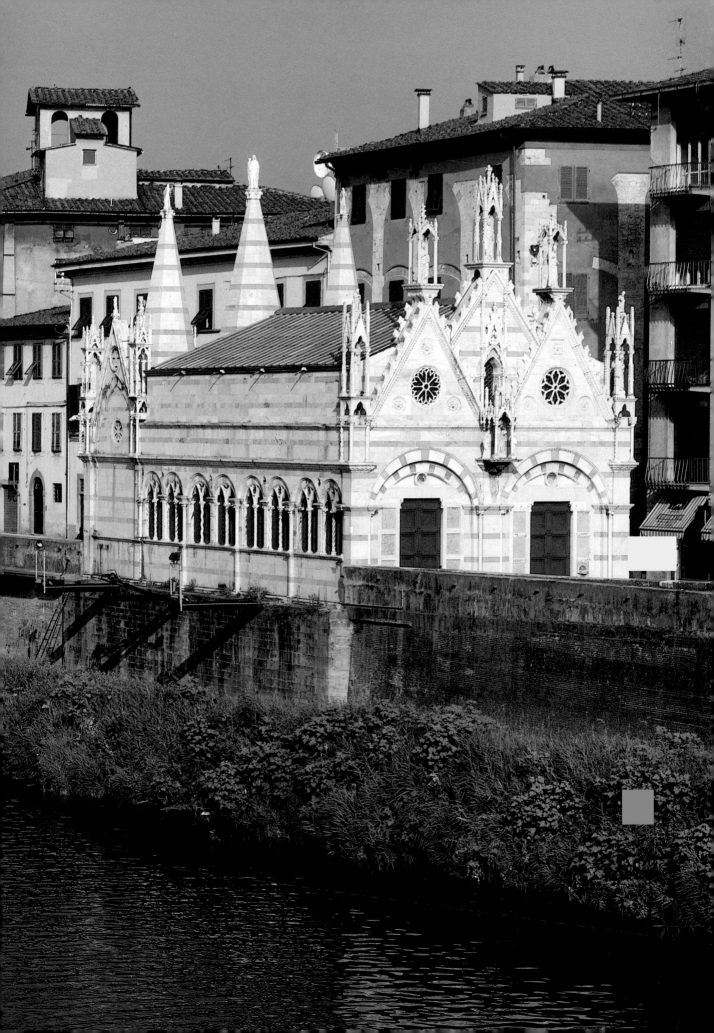

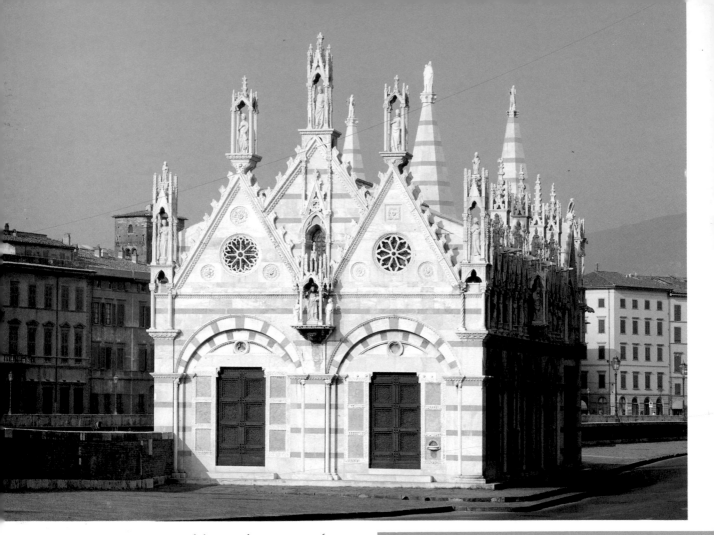

These evocative pictures reveal the marvelous structure of the Church of S. Maria della Spina, seen as a whole and close up, and its unique place in the context of the Pisan lungarni. Note the finely worked spires and pinnacles, aediculas, rose windows and sculptures in this gem of late Gothic Pisan architecture.

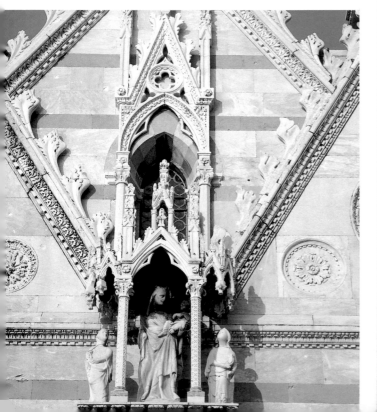

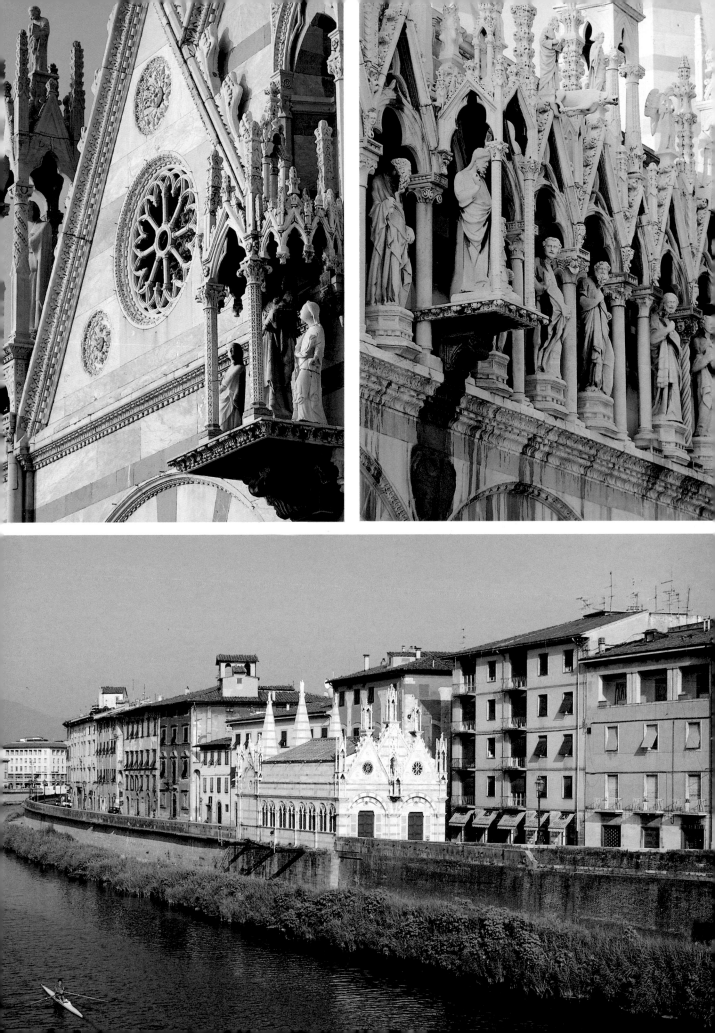

The octagonal Church of the Holy Sepulcher (Santo Sepolcro), with a pyramidal cusp, is dominated by a brick bell tower designed by Giovanni di Simone.

A striking view of the interior of the dome of the Holy ▶ Sepulcher (Santo Sepolcro), springing from pointed arches supported by piers.

The so-called Baths of Nero, near Porta a Lucca in the ▶ Republican walls, the most visible signs of the ancient Roman city in Pisa.

CHURCH OF THE HOLY SEPULCHER (SANTO SEPOLCRO)

The building overlooks the intimate little square of the same name which runs into the *lungarno Galilei*. It was built in Verrucan stone around the middle of the 12th century by the architect Diotisalvi. The fine construction is octagonal in plan, crowned by an octagonal pyramidal dome on a drum of the same shape. The church stands below street level and is enclosed by an iron fence. It originally had other architectural annexes which were eliminated in the latter half of the 19th century during a questionable attempt to redefine the urban layout of the zone. Externally the church has a row of windows (two on each facade) in the upper part, plus those in the drum (one on each side). At the corners, pilasters enliven the silhouette of the building. The principal portal has a lunette with the portrait of *Diotisalvi*, by a 19th-century sculptor, while the side portals are decorated with curious masks. The church is an important example of Romanesque architecture. It is flanked by a mighty bell tower in brick, pierced by two-light openings and with unsupported arches. Originally a chapel for the hospice of the *Order of the Templars*, it was subsequently, when the order was suppressed (1312), acquired by the Teutonic Knights and by those of Malta. The **interior** is striking in its solemn austerity, a bare but evocative space, of great interest architecturally. The high central dome springs from a succession of large pointed arches supported by robust piers.

Of particular note is the *tombstone of Maria Mancini Colonna*, mistress of Louis XIV of France, who died in Pisa in 1715.

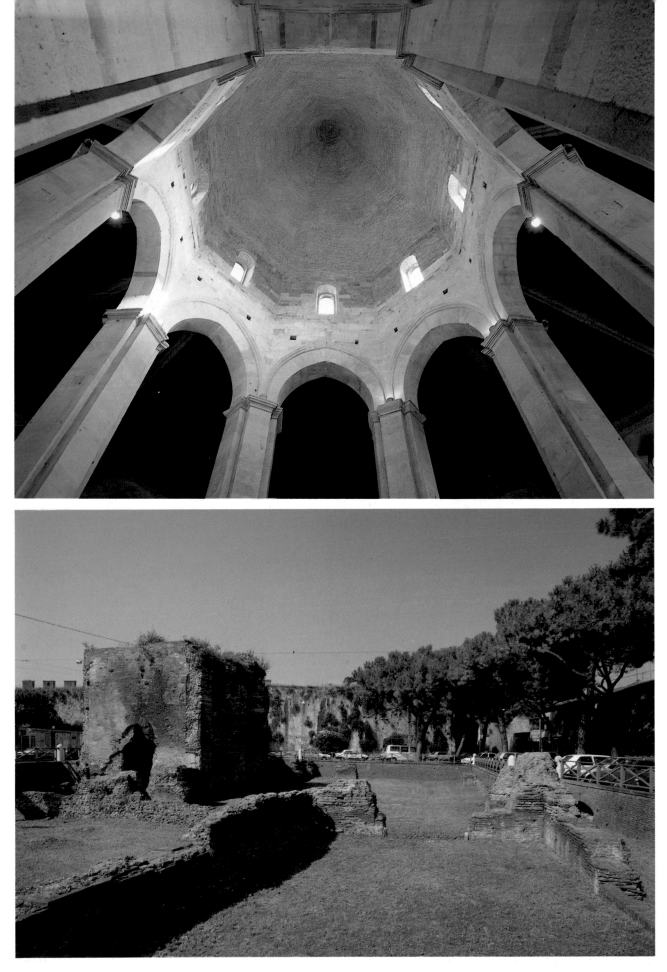

A haunting picture of the Luminara of S. Ranieri (evening of June 16th).

Gioco del Ponte (last Sunday in June): the representatives of 'Mezzogiorno' move in procession along the lungarni of 'Tramontana'.

FOLKLORE AND TRADITIONS

A city of great historical traditions, with a rich cultural heritage, Pisa puts its best foot forward in June, during the Giugno Pisano, the month that has been consecrated to «Pisanità» for decades.

Luminara di S. Ranieri (Candlelight Festivities). This event takes place on the eve of the feast of the patron saint (June 16th) and transforms the lungarni into a phantasmagoric fairy-tale setting. The architectural details of the palaces — windows, cornices, balconies — and the parapets along the river and the bridges shimmer with the reflected light of over 70,000 «lampanini» (small glass lamps burning wax or oil).

Historical Regatta of Saint Ranieri. The Regatta takes place on June 17th, the saint's feast day. It is reserved for the vessels of the four 'historical' quarters of the

Regatta of the Ancient Marine Republics (every four years); pictures of the historical procession of Pisa: banners with the symbols of the Republic (the Cross and the Eagle of Pisa), Kinzica de' Sismondi (legendary Pisan heroine).

city (S. Maria, S. Francesco, S. Antonio, S. Martino). *The race takes place rowing against the current on a 1,500 meter-long stretch of the river.*

Gioco del Ponte. *The event is held on the last Sunday in June. The Parties of Mezzogiorno (south of the Arno) and of Tramontana (north of the river) fight for possession of the Ponte di Mezzo, with each side participating with six teams. The 'Gioco' or Game, preceded by a historical procession, consists in pushing a heavy trolley into enemy territory.*

Regata delle Antiche Repubbliche Marinare. *The Regatta of the Ancient Maritime Republics is held every four years. After a rich historical procession, the boats of Amalfi, Genoa, Pisa and Venice race each other against the current over a distance of 1,800-2,000 meters.*

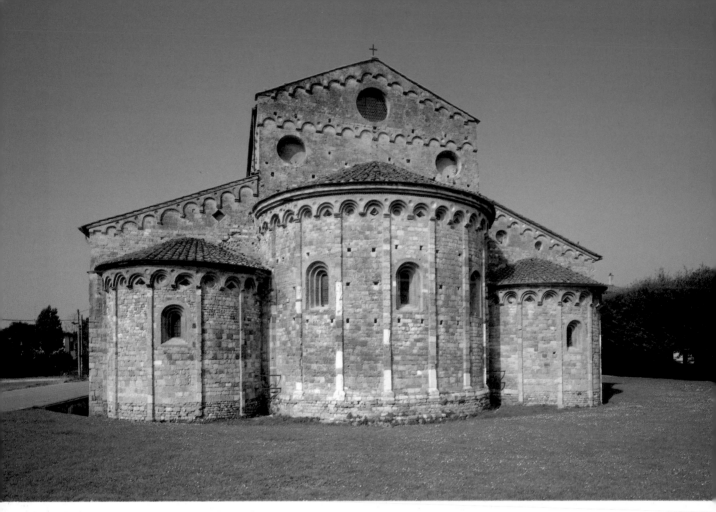

The stupendous tripartite apse of the Basilica of
S. Piero a Grado.

BASILICA OF SAN PIERO A GRADO

Driving along the tree-shaded *viale d'Annunzio* as it skirts the last stretch of the Arno and joins the city to Marina di Pisa, the lovely forms of the basilica stand out against the green countryside, where the road forks off for S. Piero a Grado, a hamlet of Pisa. The name derives from the Latin expression *ad gradus*, which meant a landing on the left bank of the Arno.

It was here, according to tradition, that the apostle Peter landed on his way to Rome from Turkey, and where he said Mass on an improvised altar which was the nucleus of the original church, consecrated by Clement I. According to a more reliable version, the present structure was built in the 11th century on a pre-existent early Christian oratory of the 4th-5th century.

The basilica is an evocative example of Pisan Romanesque, stately and imposing in the bare essentiality of the materials (tufo and white and black marble). Of particular interest are the four apses (three facing east and one west) while there is only the barest hint of a facade, identified by experts in various ruins that are to be found next to the western end of the building. Only the base of the original Romanesque campanile is left, near the west apse. This elegant complement of the basilica was swept away by German mines and was never rebuilt. The ornamental motives outside, along the sides and the apses — slender pilasters, blind arcading and majolica bowls of Islamic make — are particularly fine.

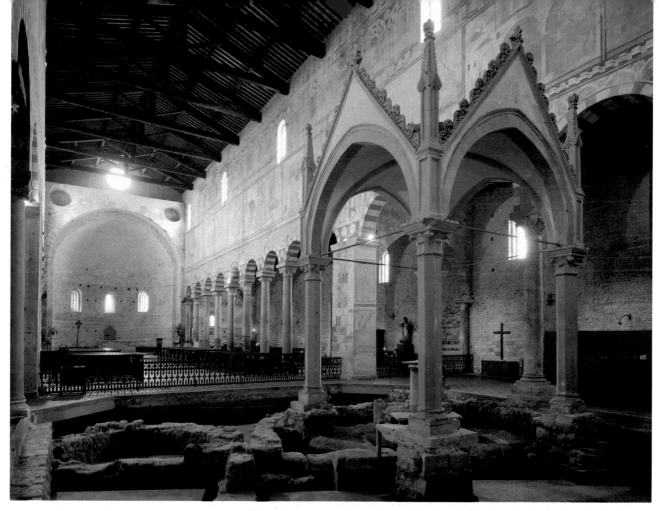

Two pictures of the majestic and austere basilical interior of S. Piero a Grado with its frescoes, ciborium and remains of the early Christian church.

The **interior,** monumental and spacious as befits a Christian basilica, is divided into a nave and two aisles by large columns with fine capitals which support red and white banded arches. The long line of *Popes* above the arches, and the frescoes on the wall depicting *Events in the Life of St. Peter* are by the Luccan artist Deodato Orlandi (14th cent.). The auster bare nature of the church and the imposing wooden trussed roof lend the space an impressively evocative air. In the west portion of the church the remains of an early Christian place of worship have been brought to light, oriented differently than the present basilica. Of note is a 14th-century ciborium, set above the altar on which St. Peter himself is said to have officiated.

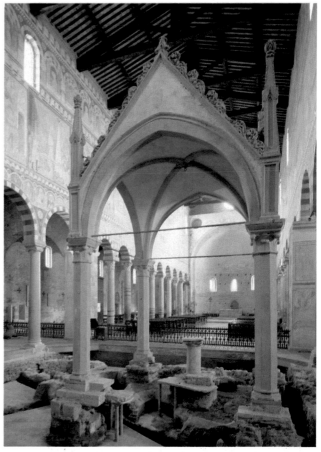

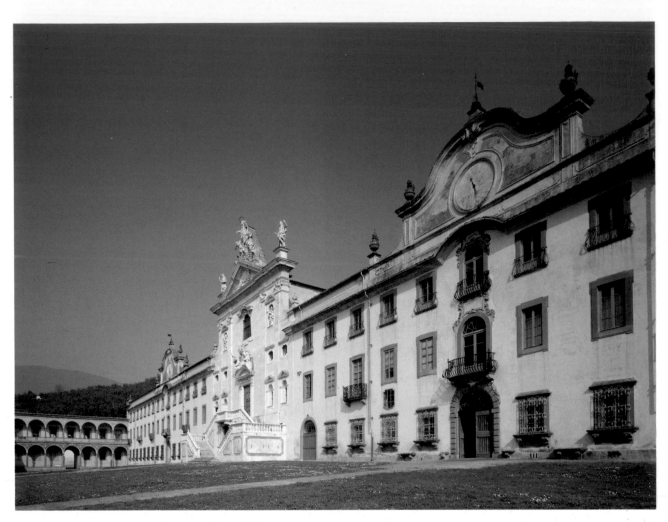

A fine picture of the Certosa of Pisa, in Calci, and the spacious court in front.

CERTOSA OF PISA

Not far from the inhabited center of Calci, with the haunting natural amphitheatre of *Monte Pisano* in the background, is Valgraziosa, an idyllic and serene country landscape, ennobled by the labor of man who has grown olives here for centuries, and who also settled on the valley floor and the lower spurs of the foothills. The imposing building complex of the Certosa of Pisa fuse into this setting of peace and industrious tranquility, with the modern television repeaters of *Monte Serra* (917 m, the highest peak of Monte Pisano) and the medieval remains of the **Rocca della Verruca** (12th cent.) on high.

The main **facade**, spread out horizontally, is clearly visible from a distance, a white mass that contrasts with the natural setting. At the center of the long 17th-century forepart is the entrance, set under a Latin motto, while further down a clearly visible inscription *(Cartusia Pisarum fundata AN.R.S. MCCCLXVI)* documents the year of the foundation of the complex (1366). The facade, with three rows of windows, overlooks a delightful green lawn. It is interrupted at the center by the marble front of the main church, which can be reached via two flights of stairs, set between two wings. The facade is crowned by 18th-century superstructures with a clock.

The **interior** of the church, dedicated to the *Madonna and St. John Evangelist,* consists of a single Baroque nave. A marble transenna, on which is a papier-mâché copy of a sculpture of *Jesus on the Ground below the Cross,* divides the area reserved for the lay brothers from those of the monks. Wooden choir stalls line the walls of the nave while a fine 18th-century *Angel,* by artists close to Bernini, stands at the center of the floor. Outstanding works of art include *The Certosa Offered by St. Bruno to the Madonna,* a canvas by Volterrano (17th cent.) on the high altar, *St. Brunone Kneeling,* by Jacopo Vignali (17th cent.) in the *Cappella di S. Bruno.* The *Blessed Niccolò Albergati between Saints Francis of Sales and Gorgonio,* by Agostino Veracini (18th cent.) in the *Cappella del Capitolo.*

Mention must be made, among the various rooms of the monastic complex, transformed more than once

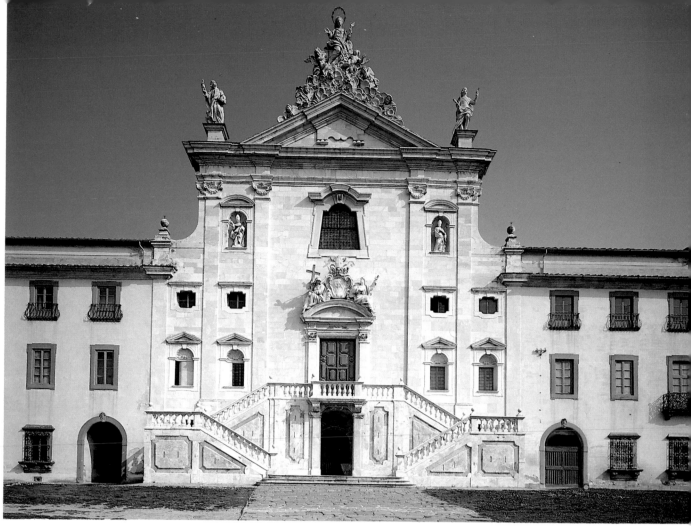

Certosa of Pisa: the facade of the church.

Certosa of Pisa: a detail of the double loggia which serves as backdrop for the entrance court.

between the 17th and 18th centuries, of the *Sala Granducale*, frescoed by the 18th-century artist Pietro Giarrè and decorated with stuccoes by Somazzi; the *Chapter Cloister* with a 17th-century well; the *Refectory* with 17th-century paintings by Poccetti; the small *Cloister of the guest quarters* with a well and a double loggia; the lovely **Great Cloister** with a fascinating 17th-century portico and a splendid Baroque fountain crowned by a 17th-century *Madonna*. The cloister shaded by cypresses, with the monks' cells and the small graveyard, is full of atmosphere. The archives of the Certosa contain fine choir books and other illuminated volumes (12th cent.). Of interest also the Pharmacy with outstanding 18th-century wooden carvings. In 1973 the Certosa, returned to the State by the monks, became an important **Historical-Artistic Museum.** In 1981 the interesting **Museum of Natural History and of the Territory** was moved here from Pisa. It belongs to the University, and contains collections of Zoology, Comparative Anatomy, Geology, Paleontology, Mineralogy and Lithology.

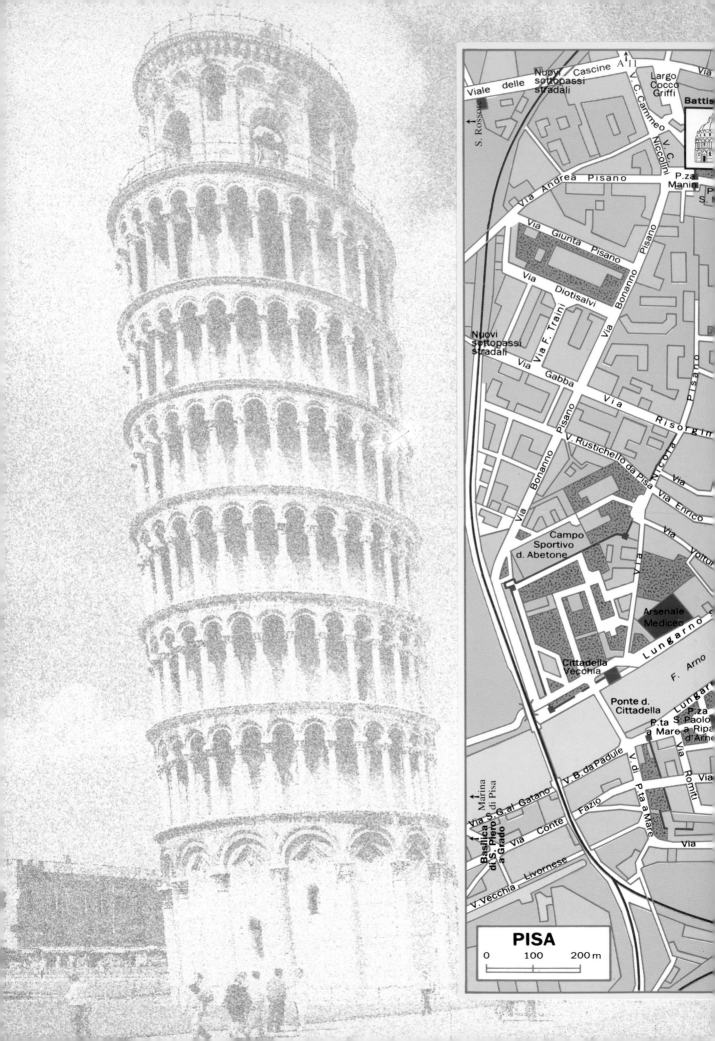

PISA

Map labels:

Viale delle Cascine
Nuovi sottopassi stradali
S. Rossore
A 11
V. C. Cammeo
V. C. Niccolini
Largo Cocco Griffi
Battis...
P.za Manin
P.za S...
Via Andrea Pisano
Via Giunta Pisano
Via Bonanno
Via Diotisalvi
Via F. Traini
Via Bonanno
Nuovi sottopassi stradali
Via Gabba
Via
Via Risorgin...
Pisano
V. Rustichello da Pisa
Via Enrico
Via Voltu...
Campo Sportivo d. Abetone
Via Bonanno
Arsenale Mediceo
Cittadella Vecchia
Lungarno
F. Arno
Ponte d. Cittadella
Lungar...
P.ta S. Paolo a Mare
P.za S. Paolo a Ripa d'Arno
Via Marina di S. Piero a Grado
Basilica di S. Piero a Grado
Via G. al Gatano
V. B. da Padule
V. di P.ta a Mare
Via Romiti
Via
Via Conte Fazio
Livornese
V. Vecchia

0 100 200 m

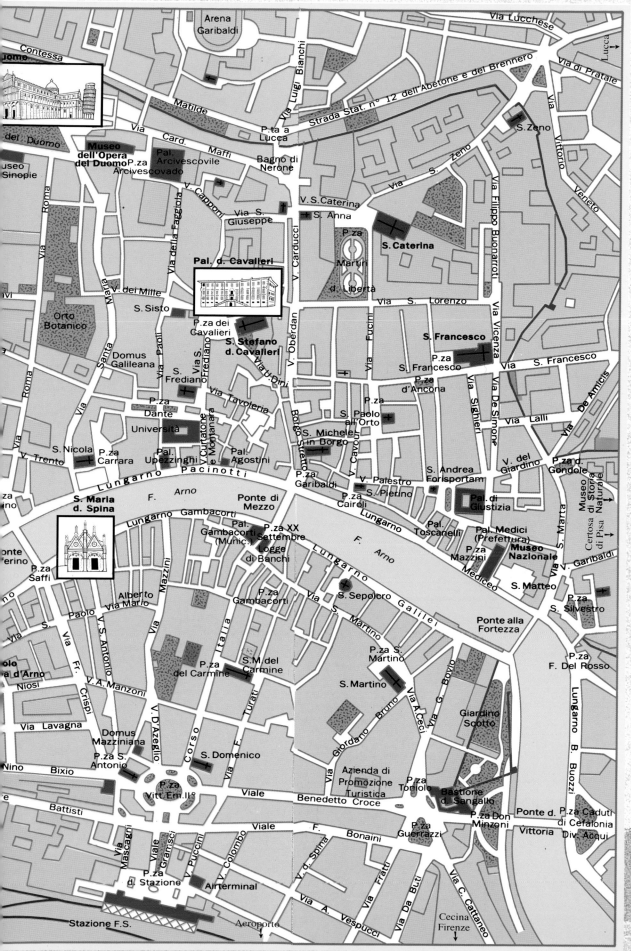

INDEX